Artist's Photo Reference
LANDSCAPES

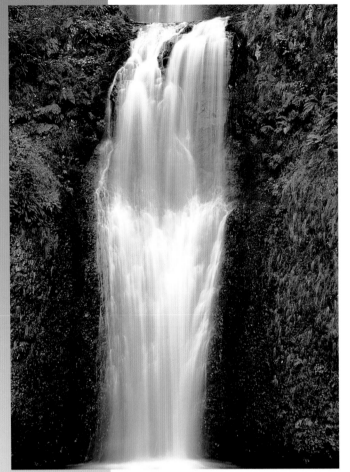
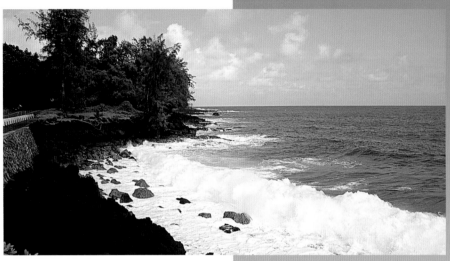
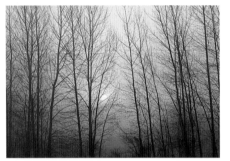
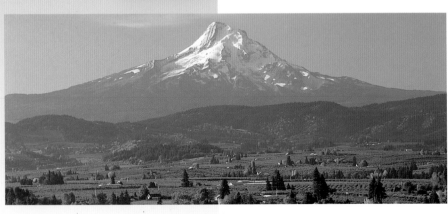
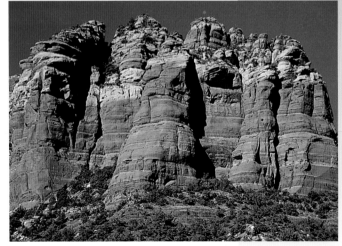

Artist's
Photo Reference
LANDSCAPES

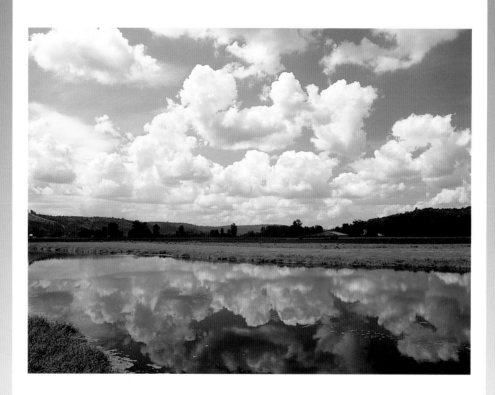

GARY GREENE

NORTH LIGHT BOOKS
CINCINNATI, OHIO
www.artistsnetwork.com

ABOUT THE AUTHOR

Gary Greene has been involved with photography since 1974. After moving from southern California to the Seattle, Washington, area, Gary started his own art, photography and graphics design business in 1984.

Gary specializes in outdoor photography concentrating primarily on natural and travel scenes. His photographs have been published by (among many others) the National Geographic Society, Hallmark, US WEST Direct, the Environmental Protection Agency (EPA), Hertz, the Automobile Association of America (AAA), *Petersen's Photographic* magazine, *Popular Photography* and *Oregon Coast* magazine.

In addition to being an accomplished professional photographer for over twenty years, Gary is a fine artist, author and instructor. His books include *Artist's Photo Reference: Flowers*, *Artist's Photo Reference: Buildings & Barns*, *Creating Textures in Colored Pencil*, *Creating Radiant Flowers in Colored Pencil* and *Painting With Water-Soluble Colored Pencils*, all published by North Light Books.

Both Gary's photographs and colored pencil paintings have won numerous national and international awards. Gary has conducted workshops, demonstrations and lectures on photography and colored pencil since 1985.

Artist's Photo Reference: Landscapes. Copyright © 2001 by Gary Greene. Manufactured in China. All rights reserved. By permission of the author and publisher, the photographs in this book may be photocopied for reference purposes, but under no circumstances may they be resold or republished. No other part of the text in this book may be reproduced in any form or by any electronic or mechanical means including information storage and retrieval systems without permission in writing from the publisher, except by a reviewer, who may quote brief passages in a review. Published by North Light Books, an imprint of F&W Publications, Inc., 4700 East Galbraith Road, Cincinnati, Ohio 45236. (800) 289-0963. First paperback edition 2003.

Other fine North Light Books are available from your local bookstore, art supply store or direct from the publisher.

07 06 05 5 4 3

Library of Congress has catalogued hardcover edition as follows:

Greene, Gary.
 Artist's photo reference. Landscapes / Gary Greene.
 p. cm.
 Includes index.
 ISBN 0-89134-998-7 (hardcover) ISBN 1-58180-453-9 (pbk: alk. paper)
 1. Landscape photography. 2. Landscape painting—Technique. I. Title.
TR660.5.G74 2000
779'.36—dc21 00-034854
 CIP

Editors: Stefanie Laufersweiler and James Markle
Cover and interior designer: Wendy Dunning
Interior production artist: Lisa Holstein
Production coordinator: John Peavler

ACKNOWLEDGMENTS

A special thank-you goes to Roy and Teri Inouye, who schlepped me all around Oahu for five days so I could get reference photos. To Prolab for their superb and timely work, and again, to my wife, Patti, for her patience and understanding (although the scenery was easy for her to take).

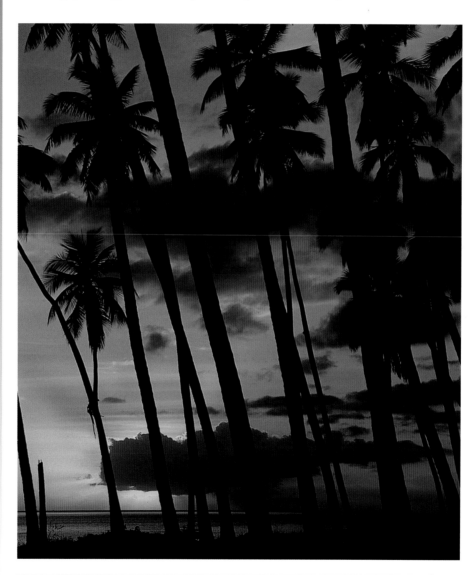

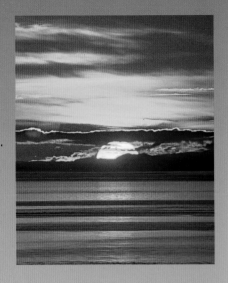

TABLE OF CONTENTS

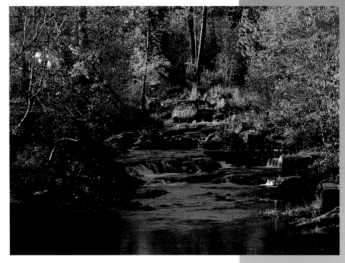

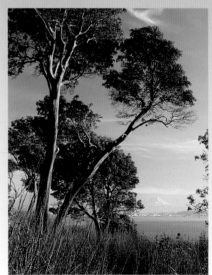

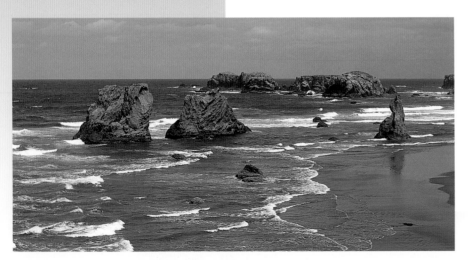

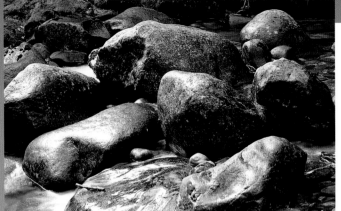

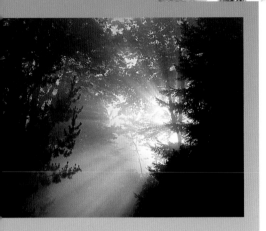

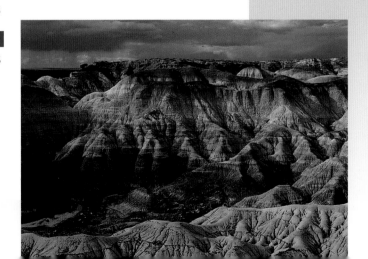

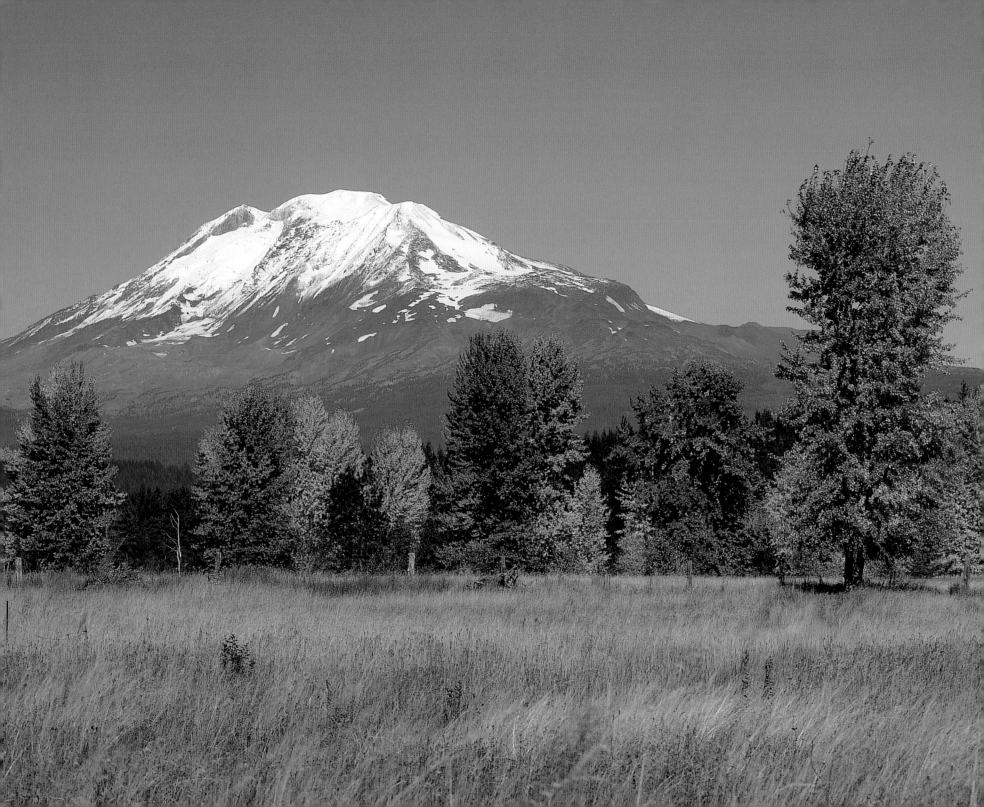

INTRODUCTION

This is my second *Artist's Photo Reference* book for North Light. It contains landscape photographs designed to use as references for your paintings or drawings. The purpose of the *Artist's Photo Reference* series is to save artists' precious time finding reference material, to provide reference photos of geography not accessible to some artists, and to furnish landscape photographs made specifically for the artist in mind. You may freely use these photographs as references, as long as you don't exactly replicate the photographs and attempt to publicly exhibit or sell them as original artwork.

A majority of the images in *Artist's Photo Reference: Landscapes* were made in the Pacific Northwest, a region which boasts a wide variety of geographic and climatological features, from lush rain forests to arid deserts; from rugged, snow-capped peaks to beaches laden with miles of driftwood. The Southwest, a favorite region for painters (and photographers too), is also well represented, with deserts, canyons, colorful cliffs and mysterious sandstone structures known as "hoodoos."

Do you want to make your landscape paintings more exciting? Add dramatic clouds! This book offers many examples of clouds, depicting all kinds of weather conditions and seasons of the year. You'll also find sunsets, rainbows and foggy scenes in the skies chapter.

Would you like to paint a pristine, reflective lake in a verdant forest of evergreens, or a raging river flowing over lichen- and moss-covered rocks, or maybe a lonely ocean beach with the surf pounding on jagged rocks? They're all here, plus much more!

Artist's Photo Reference: Landscapes also features six step-by-step demonstrations by experienced artists working in their favorite mediums, demonstrating how they interpret selected reference photos to create stunning landscapes.

I hope this book will enlighten and inspire you to create exciting landscape art.

Gary Greene
Woodinville, Washington
November 1999

Do you ever have an overwhelming desire to paint an ocean scene but live two thousand miles from the nearest shore? Most artists can't take the time or money to book a flight to California, Hawaii or Florida at a moment's notice. Instead, they spend many frustrating hours scavenging for reference photos or try to "fake it" if they can't find the images they're looking for. With this book, you can simply turn to the water chapter and find photos to help you create an exciting "ocean-scape."

Properly Using Reference Photos

To use this book properly, *avoid* exactly re-creating the reference photos in a painting, even though it may be tempting. (However, it's not in violation of copyright laws to copy the reference photos as long as the painting or drawing is not publicly exhibited, claimed to be an original composition, or put up for sale.) Many of the reference photos are intended to depict specific elements and are not necessarily composed correctly. Instead of copying, select a main reference photo to work from, then, for example, add clouds from one photo and mountains from another, then change the lighting, crop the composition—you get the picture.

Interspersed throughout this book you'll find demonstration paintings created by professional artists working in each of the "major" art mediums. The purpose of these demonstrations is to show how you can use parts of reference photos to create an original painting.

Reference photos can be compiled by making photocopies of them, cutting out the elements you want, then pasting them together to form a collage of sorts. You may want to make an enlarged copy of the pasted-up original, but be careful, as repeated generations of copies yield poor color and loss of detail. Large photocopy centers may also be reluctant to reproduce images from this book because of copyright concerns. If this happens, show them this: **Hey, copy person: It's OK to photocopy the pictures in this book!**

If you are computer savvy, programs like Photoshop can make things much easier. Photos can be scanned, then cut and pasted together electronically (see "Creating a Composite Photo" on page 13). Your electronic composite can be printed on a laser color photocopier at your favorite copy center, or printed on your own color printer. Keep in mind that laser printers produce better color and resolution than personal ink-jet printers.

Reference photos can be invaluable, but remember that to maximize the credibility of your landscape paintings, you should try to observe actual or similar elements in their natural state whenever possible.

Taking Your Own Reference Photos

Many artists are put off by photography. Not only are they missing a chance to improve their artwork, but they also miss the creative possibilities of a truly exciting and creative medium. Others think photography is difficult and technical, but it can actually be easier to achieve good results with a basic knowledge of photography than with years of instruction and practice with painting!

You don't have to spend a lot of money on equipment to get good reference photos. A manual-focus single lens reflex (SLR) camera and a moderate zoom lens can cost as little as $225. A sturdy tripod with a standard pan head costs about $75, and a filter to protect your front lens element costs around $20. This basic outfit will be sufficient for most of your needs, unless the shutterbug bites you!

Equipment: Basics and Beyond

A 35mm SLR camera featuring interchangeable lenses is a must. So-called point-and-shoot cameras are not recommended because their optics may be inferior or they may allow little to no control over exposure, focal length or focus. APS (Advanced Photo System) cameras use film that is smaller than 35mm, not a good idea if you want sharp, detailed images.

The camera you choose need not be an autofocus model, unless you intend to shoot moving objects. Camera bodies are usually sold separately without lenses. Avoid "package deals"; unscrupulous dealers often offer inferior lenses and other equipment with camera bodies.

Lenses come in a variety of focal lengths and "speeds." They may be made by the camera's manufacturer or by manufacturers who specialize in producing only lenses. Independently made lenses are less expensive than the camera maker's and are, for the most part, comparable in optical quality.

The "speed" of the lens denotes how much light-gathering power it has. As the speed of the lens increases, so does its price and size. For landscapes, a fast lens is not necessary, especially if you are willing to use a tripod.

A zoom lens will give you a variety of focal lengths built into one lens. With today's technology, zoom lenses have excellent optics, greater ranges and are smaller, lighter and faster. An ideal zoom lens for shooting landscapes is a

Defining Focal Lengths

Under 15mm = fish-eye

15-24mm = ultrawide

28-35mm = wide-angle

45-55mm = normal

70-100mm = moderate telephoto

100-200mm = telephoto

300mm & up = long lens

28-200mm focal length. A lens with this range will be suited for 95 percent of all the photos you will want to take.

Filters screw onto the end of your lens and perform various specialized functions. You should always have a filter on your lens to protect its front element from dust and scratches. Many photographers use a clear UV or skylight filter, but I recommend an 81A filter, which is slightly orange in color. The 81A "warms up" your photos without altering them and is particularly useful on overcast days.

A polarizing filter, or polarizer, is a rotating filter that removes glare, makes skies more intense and produces richer color in your photos. Polarizers work optimally at 90-degree angles from the sun and have less of an effect as you face the sun or have your back to it. Manual-focus cameras use linear polarizers and autofocus cameras require the circular variety.

Tripods are the bane of most amateur photographers because they are clumsy, heavy and sometimes complicated to use. The bad news is you'll need a tripod to get sharp, detailed pictures. The good news is that using a tripod equipped with a ball head and quick release, instead of a standard pan head, can mitigate some of the hassles. Ball heads are like a universal joint and allow you to easily move the camera into any position without levers. A quick release

has a small plate that attaches to the bottom of your camera and frees you from using the screw mount to attach your camera to the tripod. Place the camera plate on the receptacle on the tripod and, snap, it's locked onto the tripod. Release it by just flipping a lever.

Film is to the photographer as paint is to the artist. So many film choices can be intimidating to the fledgling photographer. Should I use print or slide film? Sacrifice image quality by using faster film? What brand of film is best? There are no easy answers; film choice is as personal as choosing between painting in oils or watercolors.

Here are recommendations to help you choose the right film:

Slides are preferable to prints for several reasons. For one, slide or transparency film produces images much sharper and color-correct. Some artists work directly from slides viewed through an inexpensive photographer's loupe. A slide is placed in a clear acetate sleeve and taped to a 10x loupe. When held up to a light source, the slide is magnified to an equivalent of an 8" x 10" (20cm x 25cm) print but with infinitely more clarity. Also, the cost of shooting slides is less expensive and they are easier to store. Prints made from slides (called "R" prints) are comparable to prints from negatives.

Print film is more "forgiving" than slide film because you can miss the cor-

You may want to consider buying the following photographic equipment for shooting landscape reference photos: an SLR camera with a 28-200mm lens and an 81A filter, plus additional polarizing filters (above), and a tripod with ball head and quick release (at left).

rect exposure by a greater margin and still have a good photo. However, print film is more vulnerable to printing errors in the lab, resulting in poor color, incorrect exposure or both.

A film's speed (ISO) determines how sensitive it is to light. The faster the film (the higher ISO number), the more sensitive it is, which enables the photographer to shoot at higher shutter speeds, making a tripod unnecessary. Faster films have larger light-gathering particles in their emulsion, producing less-sharp photos.

A Photographer's Shopping List

Here is a list of useful equipment for taking landscape reference photos, with approximate prices:

Manual-focus 35mm SLR camera ($150 & up)

Autofocus 35mm SLR camera ($200 & up)

Moderate zoom lens: 35-70mm focal length ($75 & up)

Extended range zoom lens: 28-200mm focal length ($250) (recommended)

Long zoom lens: 100-400mm focal length ($500) (optional)

Protective filter: Skylight or UV ($20)

Protective filter: 81A ($20) (recommended)

Polarizing filter: ($30 & up) (optional)

Tripod with standard pan head ($75 & up)

Tripod with ball head and quick release ($125 & up) (recommended)

Camera bag: ($50 & up)

Camera vest: ($35 & up) (recommended)

Suggested slide films for landscapes are Fujichrome Velvia (ISO 50) and Provia F (ISO 100), or Kodak E100VS and E100SW (both ISO 100). Velvia is one of the sharpest films available and produces brilliantly saturated colors, even on overcast days. E100VS is twice as fast as Velvia, has excellent sharpness and yields colors even more brilliant than Velvia. Because these are professional films, don't look for them at your local drugstore. You can buy them at camera stores or photo labs. Kodachrome films (ISO 25 and 64) are also good films but may take up to two weeks to process, whereas the others can be processed in as little as two hours.

Hunting For Photos

Being outdoors and taking photographs can be as exhilarating as painting or drawing, doubly so if you use your own photographs as references! Here are a few simple guidelines for shooting successful landscape reference photos:

Light is probably the most important element in any photo. As a rule, the best natural lighting occurs two to three hours after sunrise and before sunset. Sometimes called the "golden hours," the lighting in this time period is warmer and more pleasing than when the sun is overhead. It also produces a better modeling of shadow and light because of the sun's lower angle.

An overcast sky is usually unsatisfactory for landscape photography because sunlight is scattered by the overcast, which produces photos with flat lighting and little contrast. If you feel that you can use a particular scene or element and it's overcast, go ahead and shoot it anyway and incorporate better lighting in your painting.

Composition is a consideration when shooting reference photos. You can opt to make a ready-to-paint, in-camera composition for reference, or only shoot certain elements and save them for use in future paintings. For example, let's say you're at a strip mall and see beautiful cumulus clouds billowing up in the sky. If you have your camera with you—and you should at all times—go ahead and take the photo of the clouds, regardless of unwanted objects in the scene.

If you want to compose your photograph for a painting, the same "rules" apply to photography as in painting or drawing. (See "Composing Good Photographs" sidebar.)

Once you understand the photographic process, you'll be able to make all the photos you need to create exciting paintings in your favorite medium. Maybe you'll get turned on to photography, too!

Composing Good Photographs

If you want to compose your photograph for a painting, the same "rules" apply to photography as in painting or drawing:

- Have a center of interest.
- Use the rule of thirds—divide your photograph into thirds horizontally and vertically and place the center of interest near the intersection of any of these imaginary lines.
- Include a foreground, middle ground and background in your painting.
- Use objects such as trees, bushes, rocks, etc., in the foreground to frame or lead the eye into your composition.
- Look for unusual lighting or atmospheric conditions, interesting objects, patterns or colors in your photo.

Creating a Composite Photo

Here is an example of how you can combine elements of several different photos to create an original composition. This example was completed in Photoshop, but if these types of computer programs are not available to you, a photocopier and a pair of scissors will work as well.

The foreground and distant trees from the primary photo, shown at left, began the composition. From the secondary photos, the mountains, sky and foreground tree were added to complete the final composite photo on the far right.

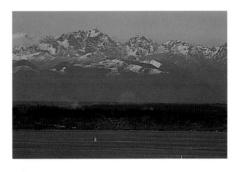

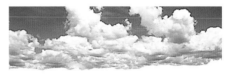

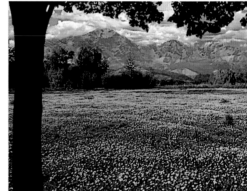

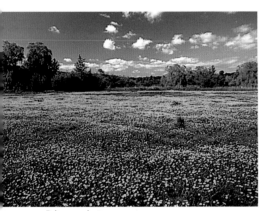

Primary photo

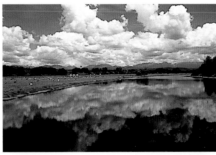

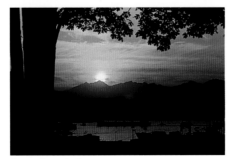

Secondary photos

Final composite photo

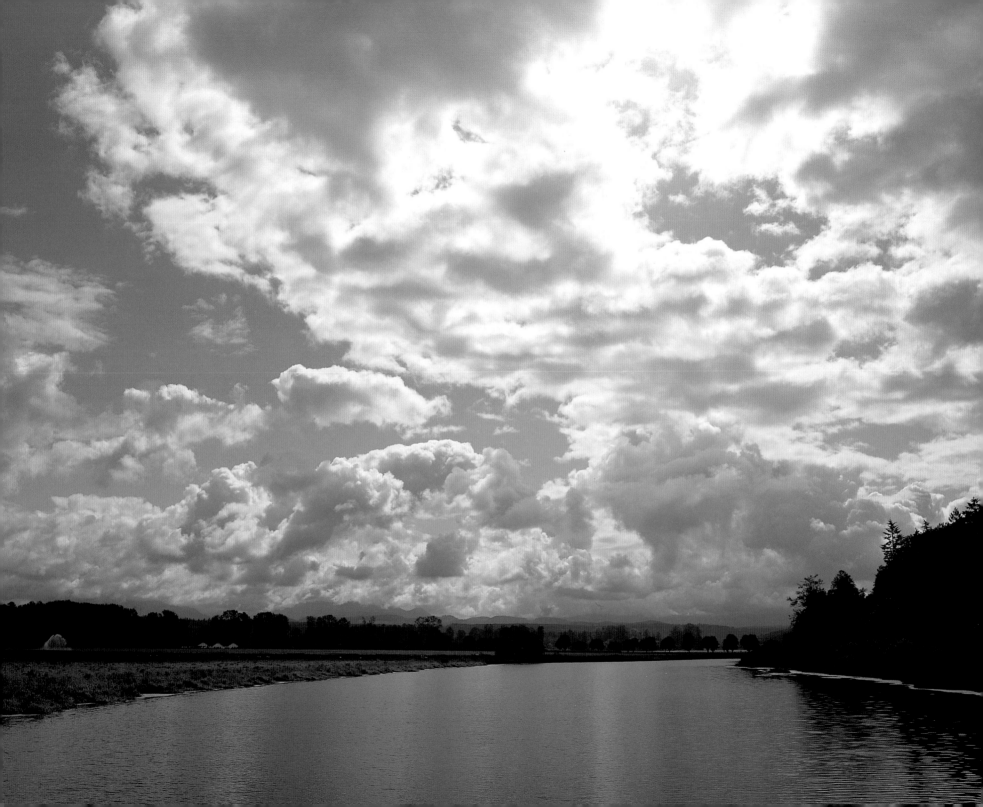

Skies

If you include the sky in a landscape painting,

nothing can enhance it more than billowing cumulus or

wispy cirrus clouds. Here you'll find clouds of all kinds,

along with other atmospheric conditions including fog

and rainbows, as well as sunsets.

Clouds

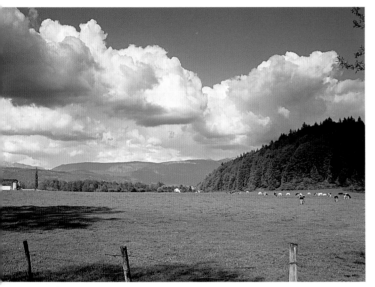

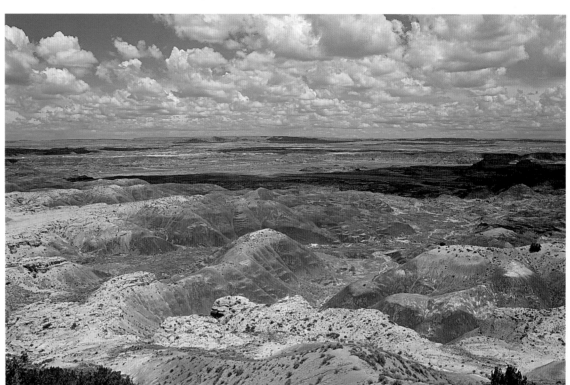

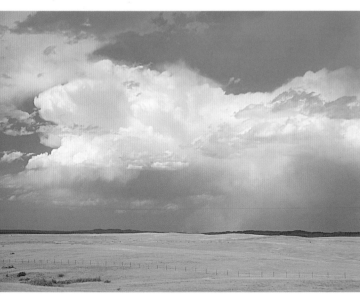

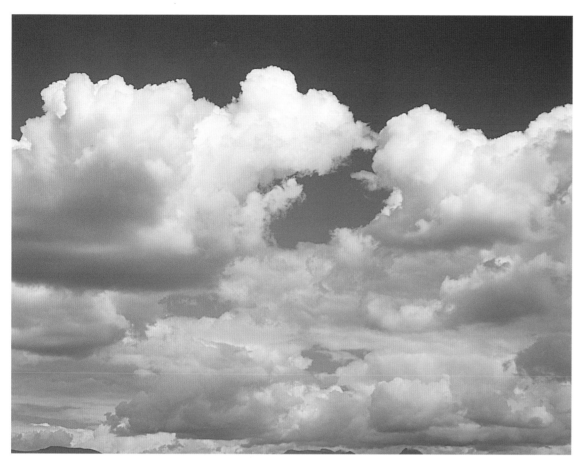
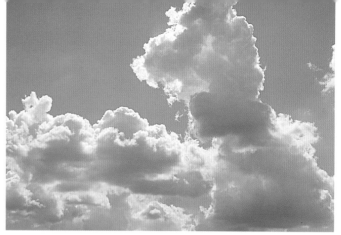
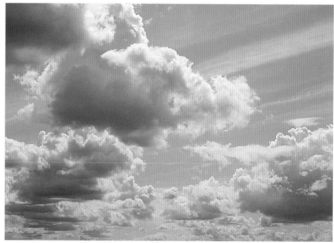
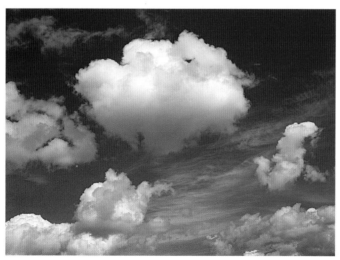
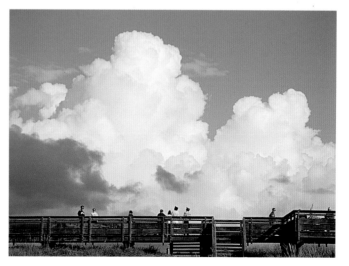

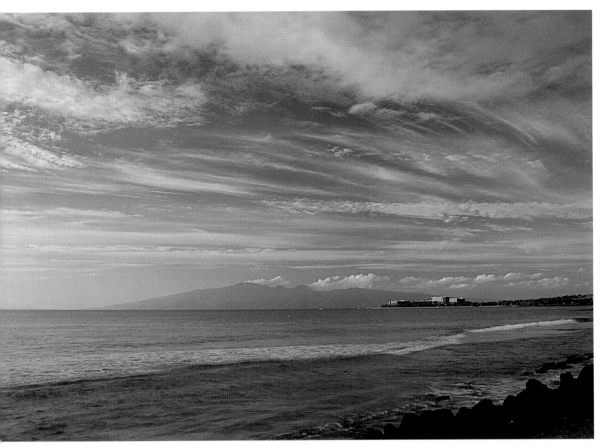

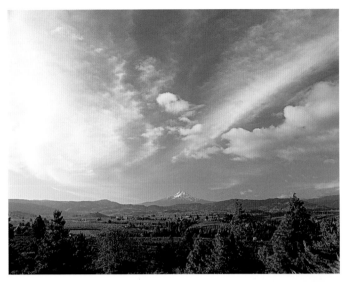

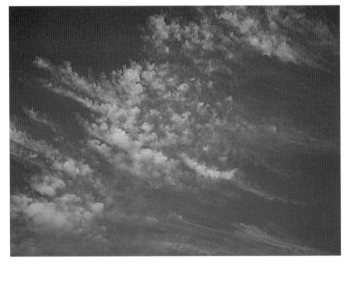

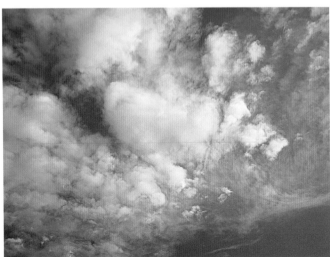

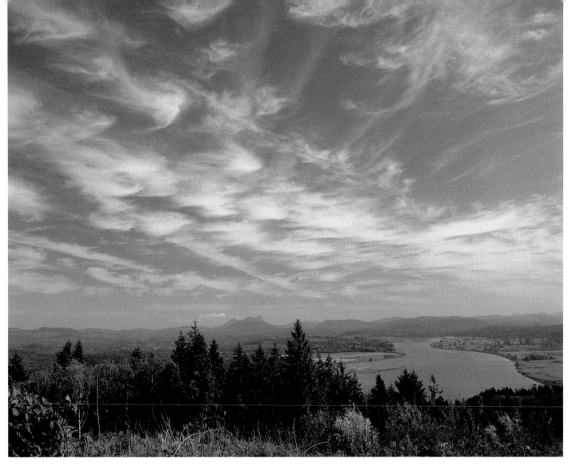

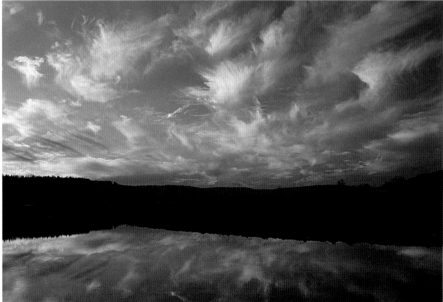

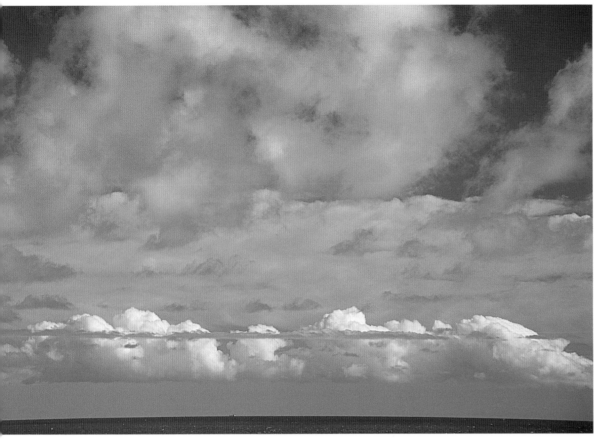

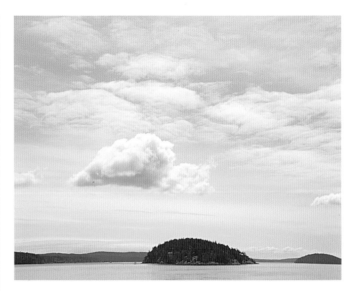

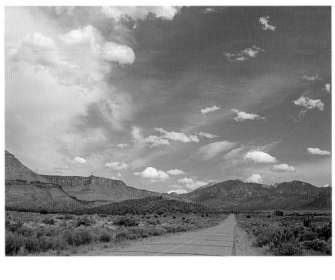

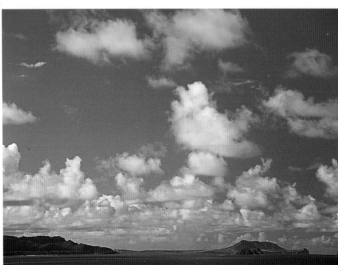

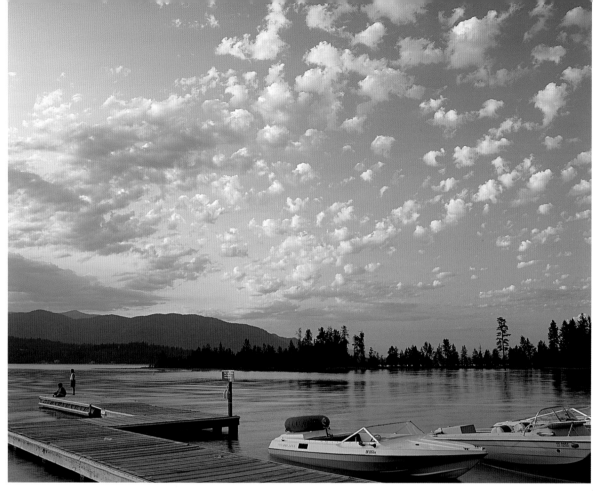

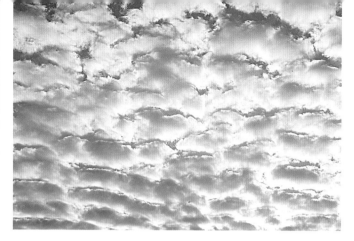

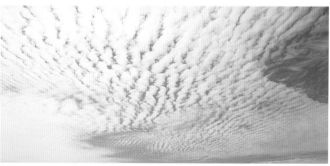

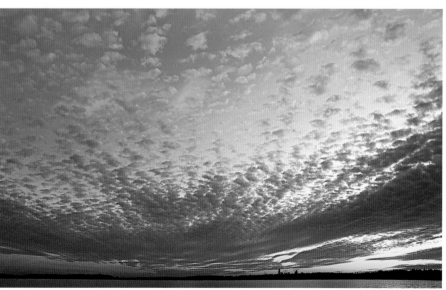

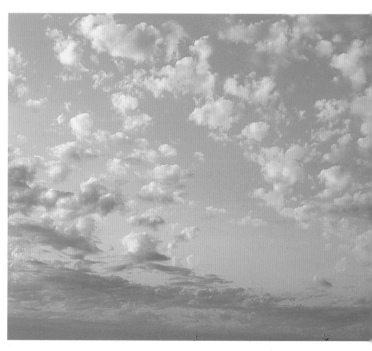

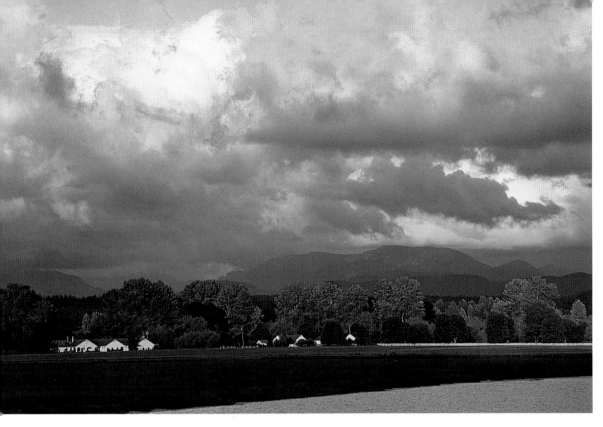

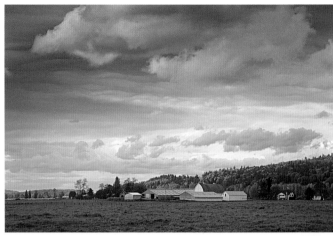

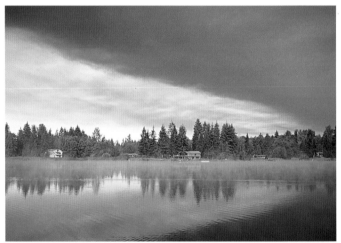

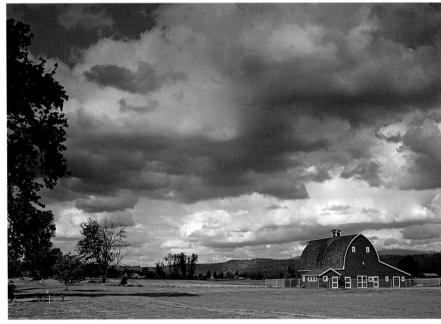

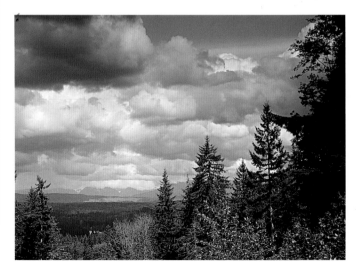

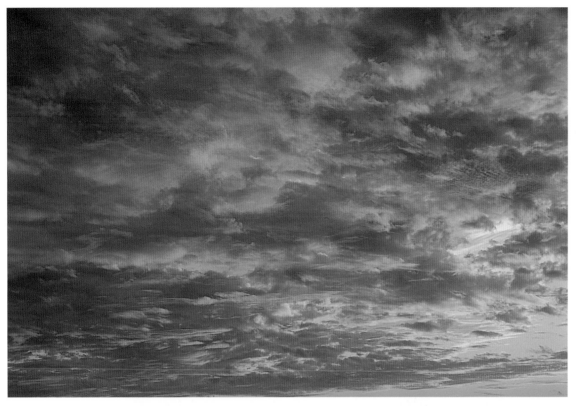

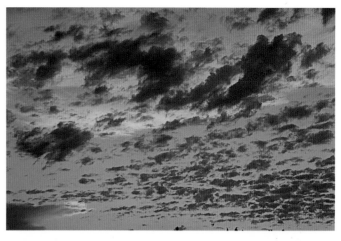

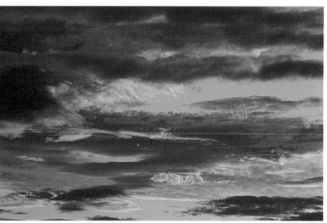

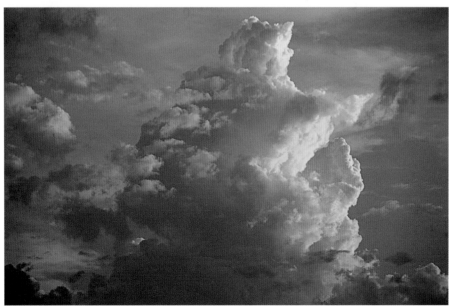

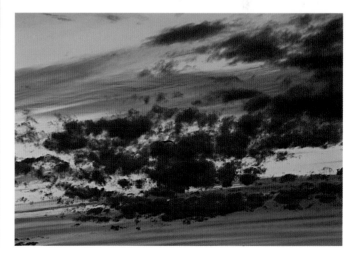

Sunrises and Sunsets

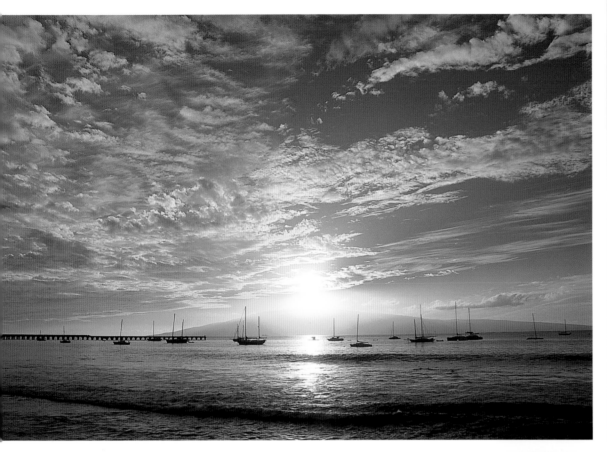

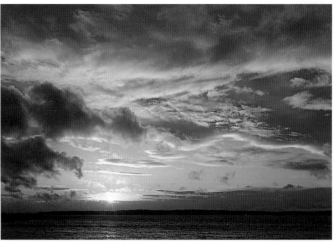

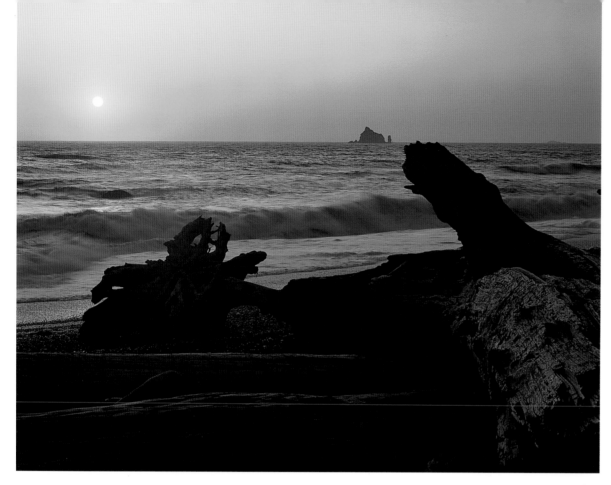

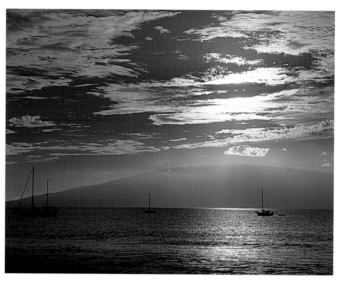

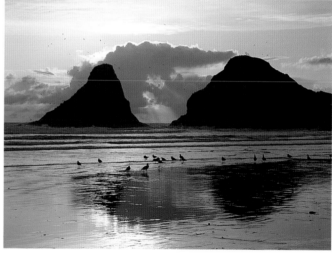

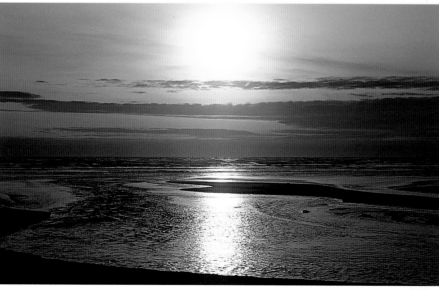

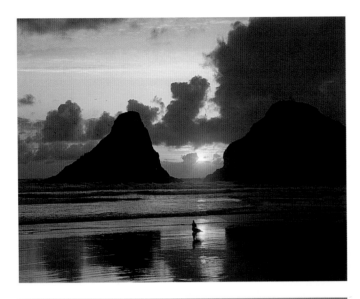

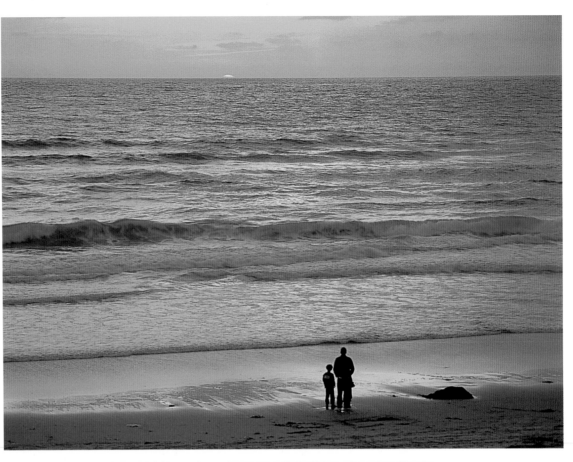

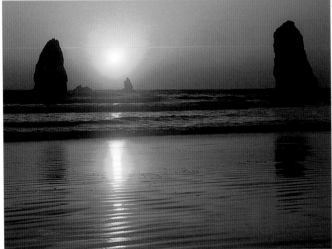

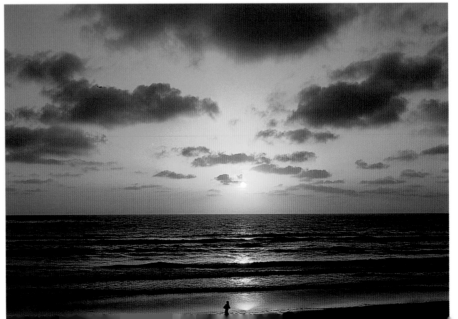

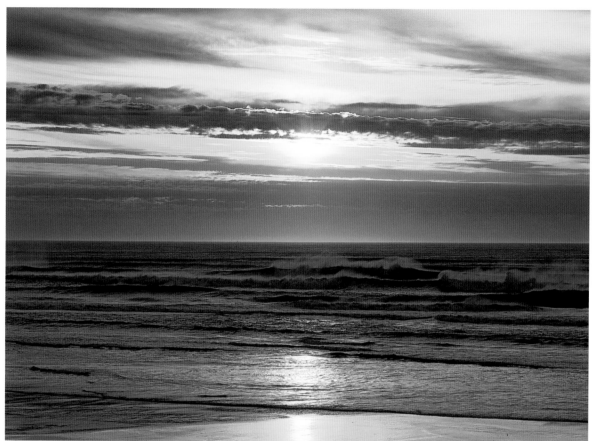

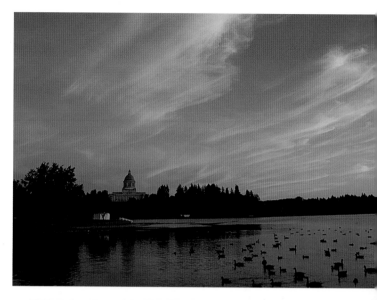

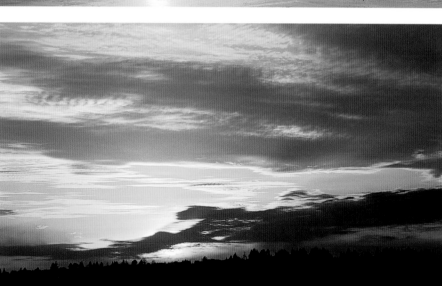

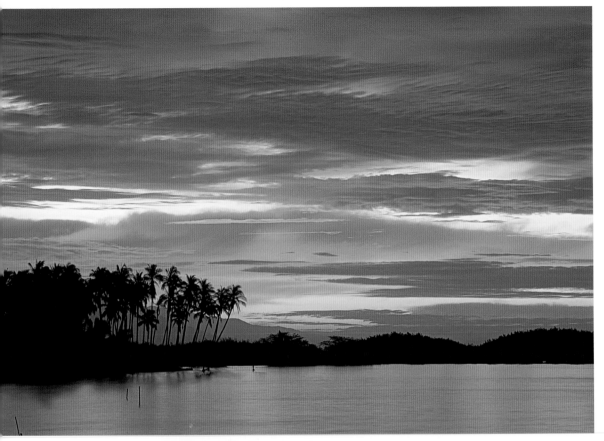
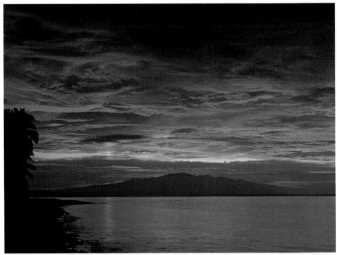
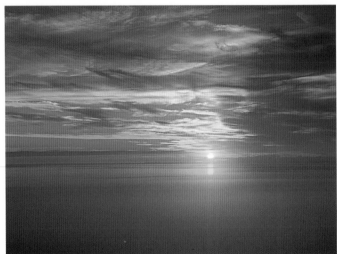
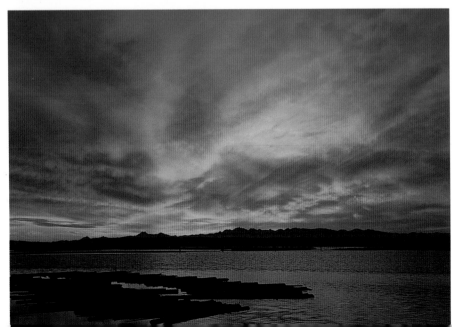

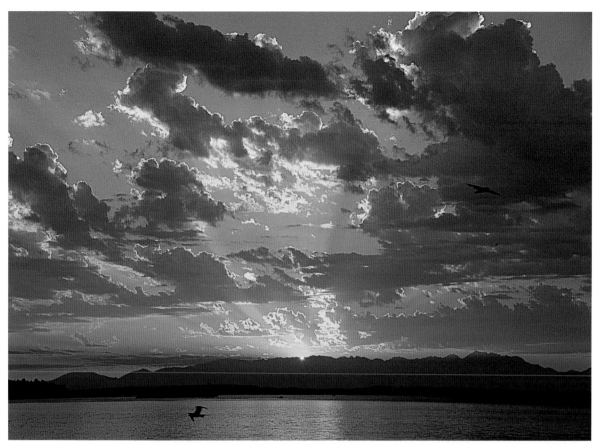

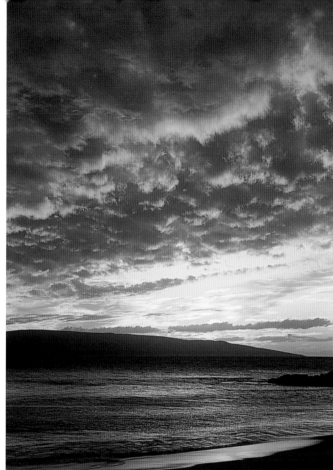

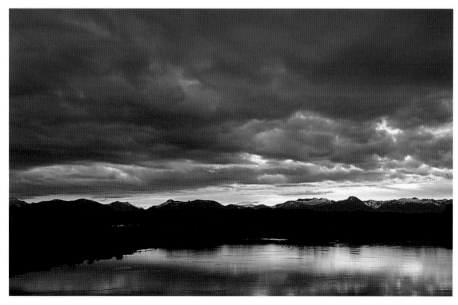

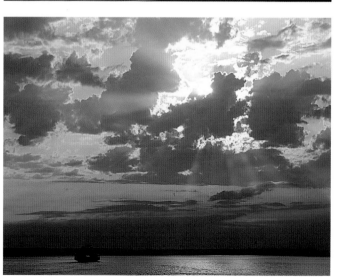

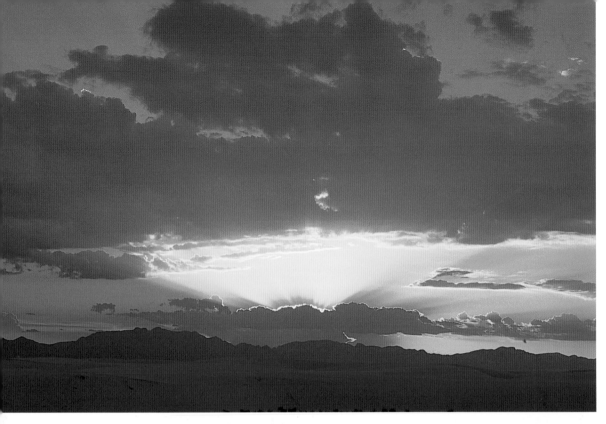

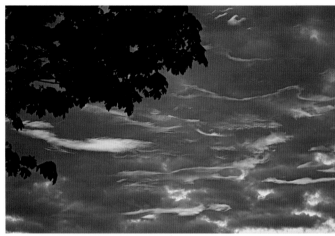

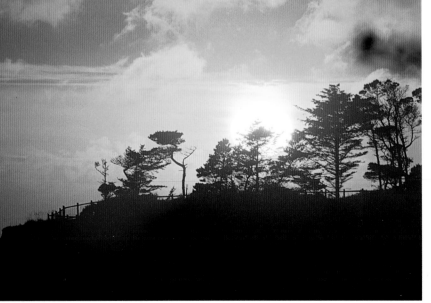

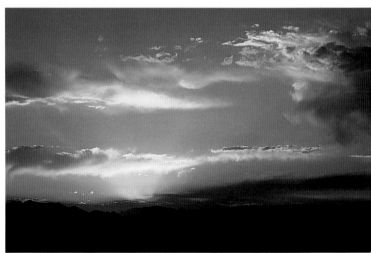

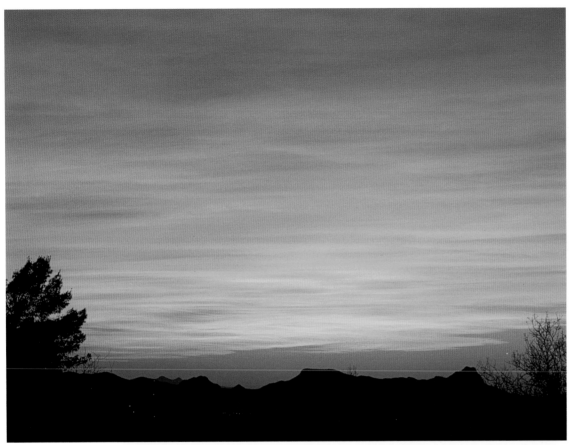

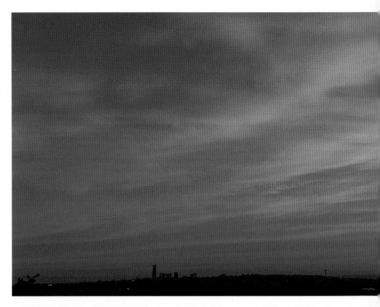

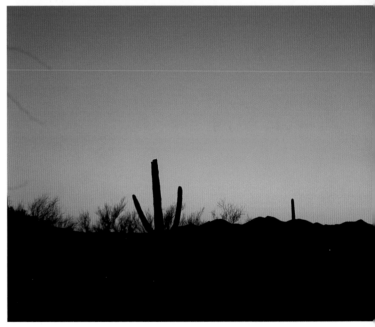

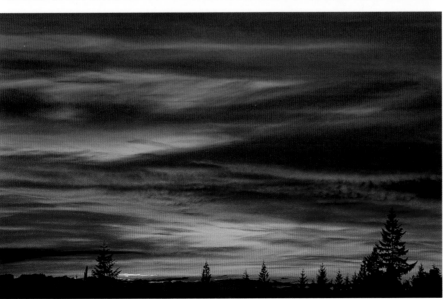

Fog

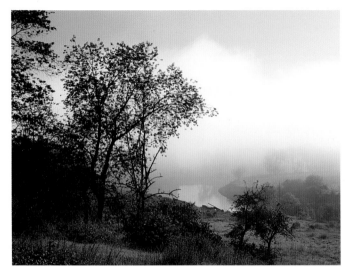

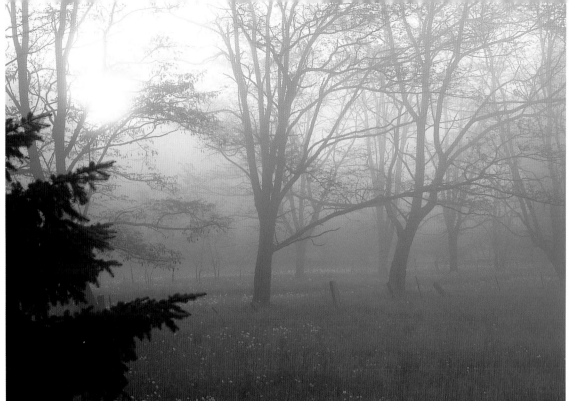

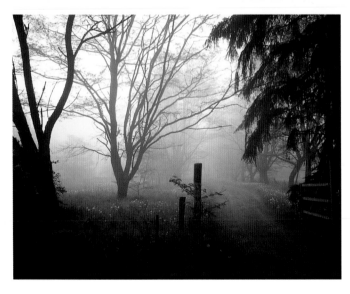

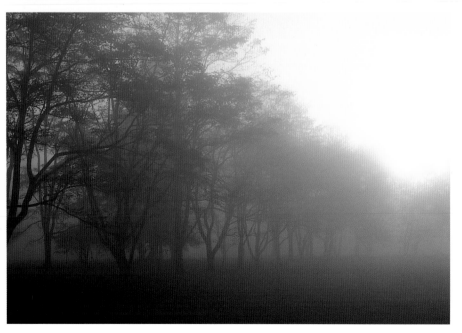

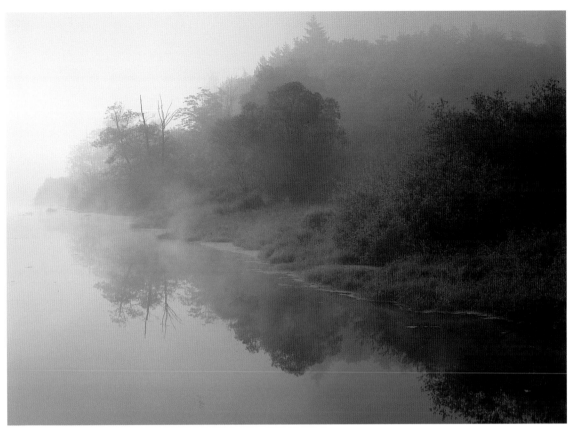

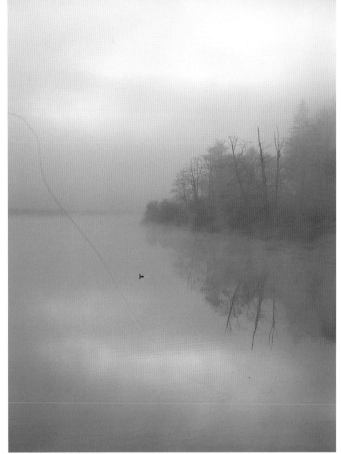

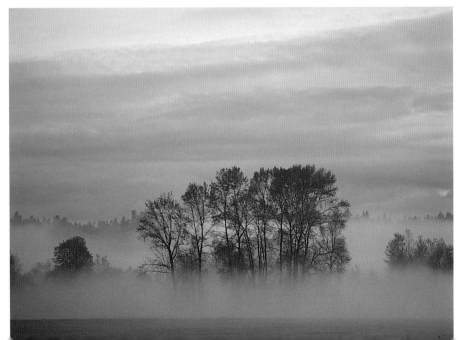

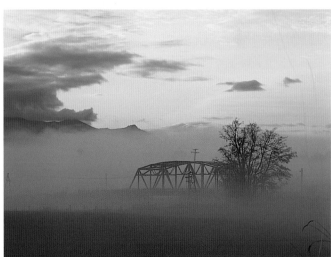

Rainbows

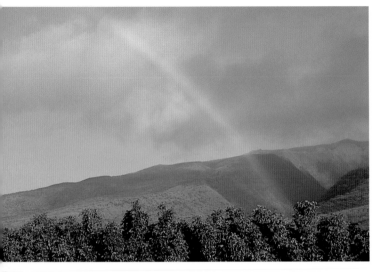

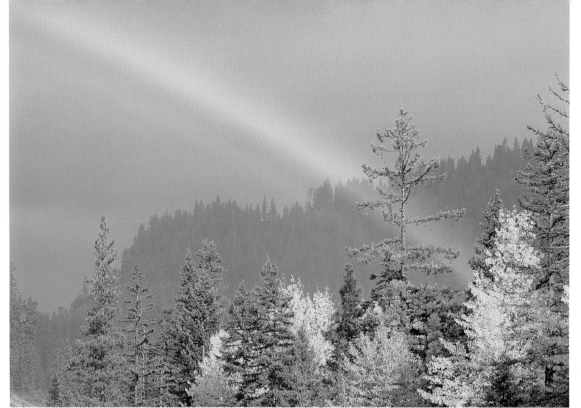

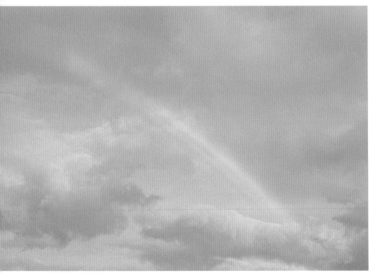

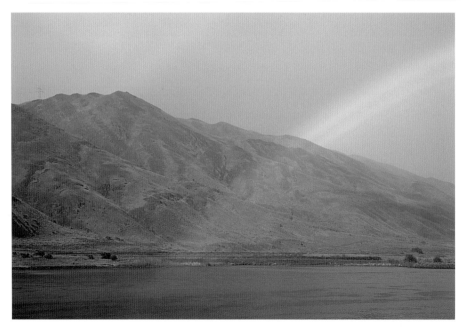

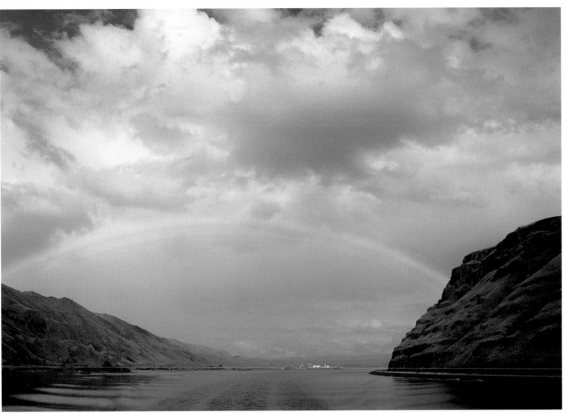

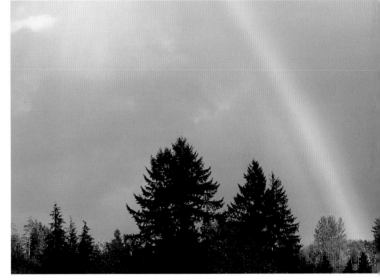

Sunset at Sea in Oil

Materials

- 1-inch (25mm) Winsor & Newton Monarch Glaze brush
- Nos. 6 & 8 Winsor & Newton Monarch short filbert brushes
- Nos. 2 and 12 Langnickel 5520 Royal Sable brushes
- No. 20 Langnickel 5523 Royal Sable brush
- Liquitex Acrylic Gesso (white)
- Liquitex Colored Acrylic Gesso (Burnt Umber)
- Winsor & Newton Liquin Alkyd Painting Medium
- Weber Martin Turpenoid (paint thinner)
- Stretched cotton canvas
- 4-inch (10cm) foam roller
- Extra-fine sandpaper
- Oval or rectangle glass or wood palette
- Trowel palette knife, with about a 3-inch (8cm) blade (for mixing paint)
- Absorbent paper towels

Color Palette

Winsor & Newton Colors—Burnt Sienna, Burnt Umber, Cadmium Red, Cadmium Yellow Medium, Crimson, French Ultramarine Blue, Mineral Violet, Payne's Gray, Raw Sienna, Titanium White, Yellow Ochre

Holbein Colors—Coral Red

This moody dusk scene was photographed on Kloea Beach in Molokai, Hawaii. Carolyn Lewis's evocative oil rendition is spectacular.

Preparation

Mix Liquitex Acrylic Gesso (white) and Liquitex Colored Acrylic Gesso (Burnt Umber) to cover the bright white of the canvas. Roll on two coats using a foam roller, and sand the canvas between dried coats with extra-fine sandpaper.

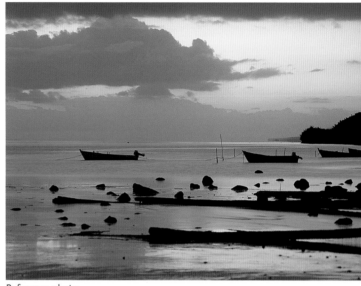

Reference photo

1. Sketch the Composition

Draw a sketch directly on the canvas with a no. 6 Winsor & Newton Monarch short filbert brush using Burnt Umber and a little paint thinner.

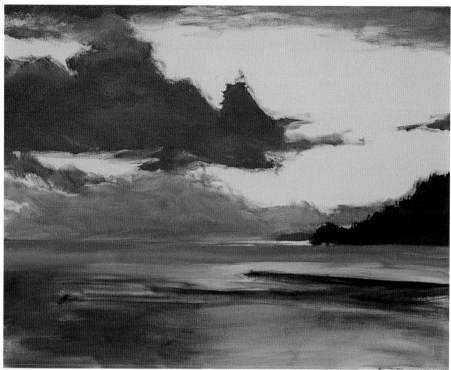

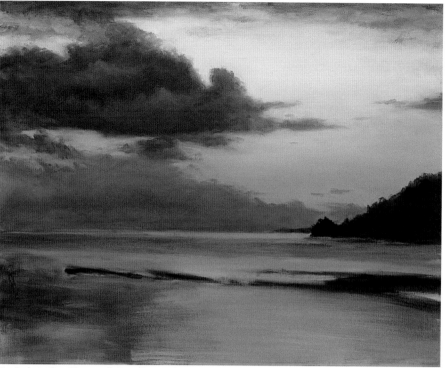

2. Mass in the Darks and Paint the Water

Start with the darkest darks, massing in local or dominant color on the hill on the right using Payne's Gray and Crimson with a little Liquin. Dab color on using a no. 12 Langnickel brush to simulate trees. Keep edges soft.

Next, mass in local or dominant color on the upper two clouds using a 1-inch (25mm) Monarch Glaze brush and Payne's Gray, Titanium White, Crimson, Raw Sienna and a little Liquin. For smaller areas and edges, use a no. 12 Langnickel brush. For the lower clouds, mass in the same way using Payne's Gray, Titanium White, Yellow Ochre and Cadmium Red.

To paint the water, rinse the brushes in paint thinner first. Using your 1-inch (25mm) brush, start applying horizontal strokes in the dark area at the horizon using Titanium White, Payne's Gray, French Ultramarine Blue and Cadmium Red. For the dark area below, use Titanium White, French Ultramarine Blue and Cadmium Red.

3. Paint the Sky and Continue the Water

If the paint on the clouds has dried, spread on a very thin coat of Liquin. Paint in the darkest part of the sky near the lowest cloud with Titanium White, Coral Red, Cadmium Yellow Medium and Mineral Violet using your no. 20 or no. 12 Langnickel brush. Move upwards toward the top of the sky, gradually getting lighter as you go by adding more Titanium White to the mixture. Soften existing edges of the clouds into the wet sky with a no.12 Langnickel brush using the same colors as for the darkest part of the sky. Paint over the existing clouds, this time bringing out different shapes within the clouds to show form.

To unify the water coloration with the rest of the painting, glaze over the bluest part of the water near the horizon using the same colors as in the foreground water (Titanium White, French Ultramarine Blue and Cadmium Red), mixed with a little Liquin. Then, sparingly glaze over the foreground water with the colors originally used for the blue water at the horizon (Titanium White, Payne's Gray, French Ultramarine Blue and Cadmium Red), thinned with a little Liquin.

4. Paint the Lighter Sky Reflections in the Water

Start with the darkest part of coral sky reflection in the water above the pier. Paint horizontal strokes of Titanium White, Coral Red, Cadmium Yellow Medium and Mineral Violet using the no. 20 Langnickel. Add more Titanium White as you work toward the bottom. Use the no. 12 Langnickel brush for the smaller areas around the pier.

Let the painting dry, then apply a thin coat of Liquin over the entire water area. Put in the rocks, pier and boat using Payne's Gray, Burnt Umber and Burnt Sienna with a no. 8 Monarch short filbert brush. For fine detail, use the no. 2 Langnickel brush.

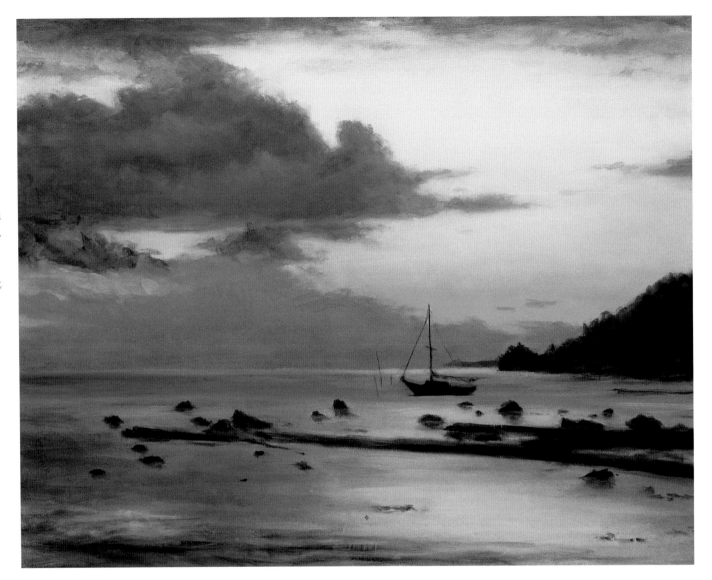

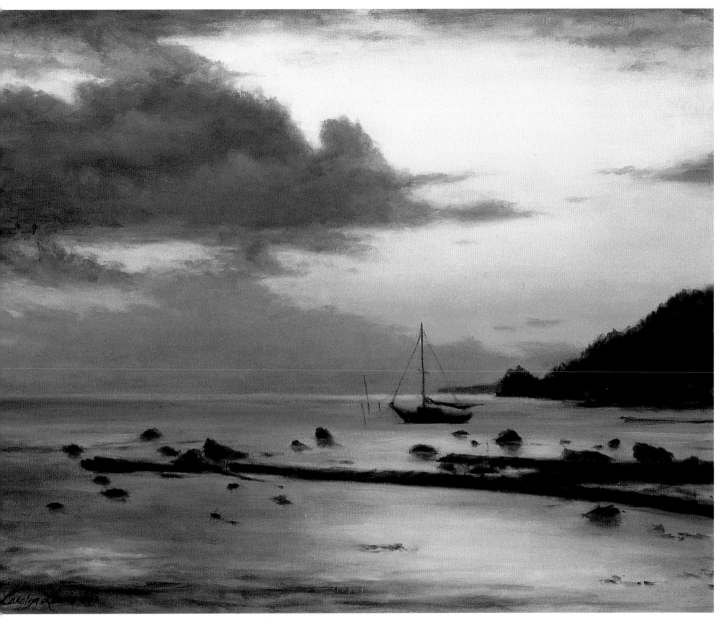

5. Add Highlights

Highlight the boat, rocks and pier using the no. 8 Monarch and the no. 2 Lang-nickel and the same colors you used for the sky and the reflections in the water (Titanium White, Coral Red, Cadmium Yellow Medium and Mineral Violet). Let the painting dry, then coat it with Liquin all over.

Evening Solitude
CAROLYN E. LEWIS
16" x 20" (41cm x 51cm)

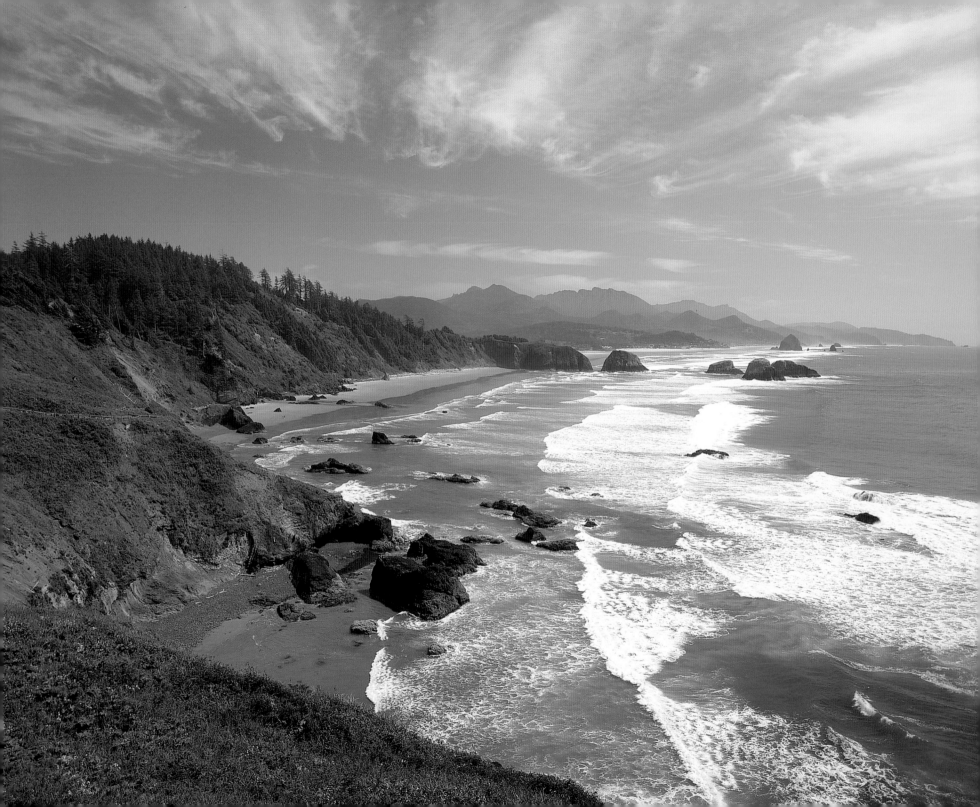

Water

Everything from crashing surf to bubbling streams

is included in this chapter, in an assortment

of geographic, seasonal and atmospheric settings.

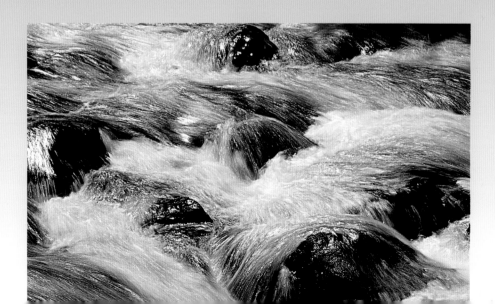

Ocean Waves

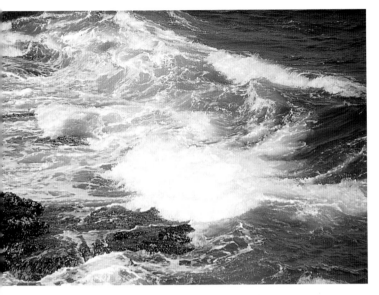

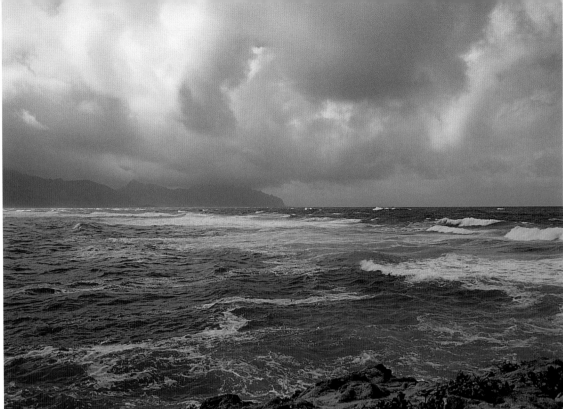

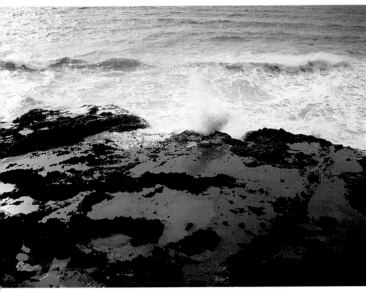

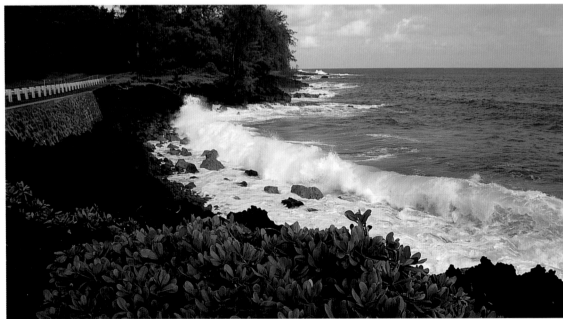

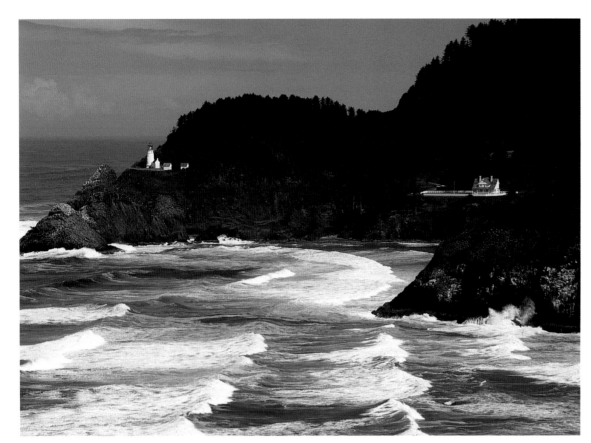
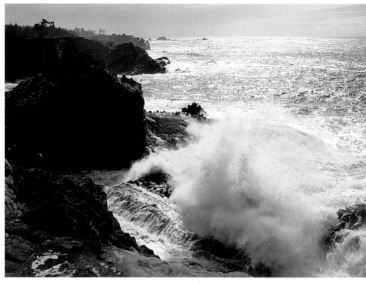
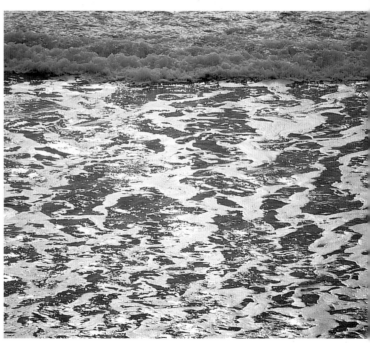
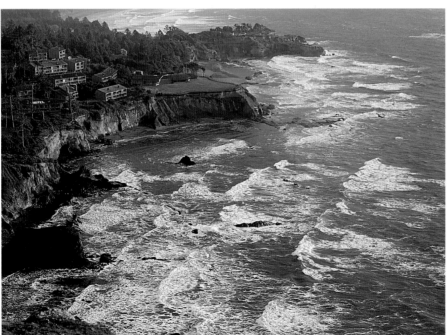

Beaches

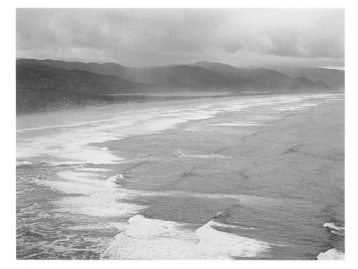

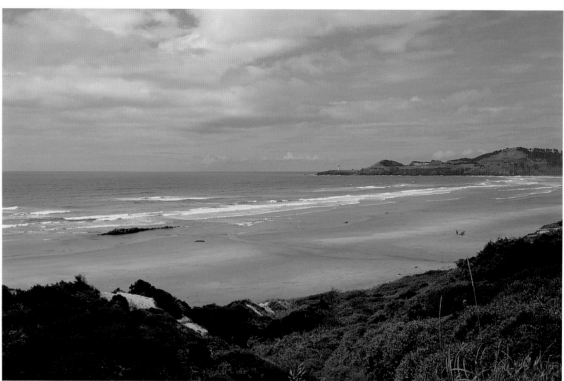

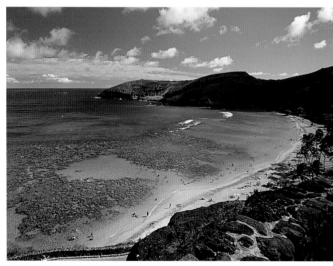

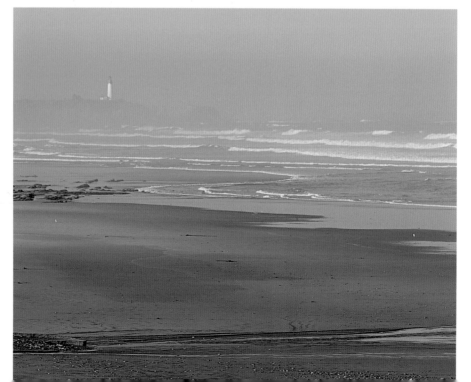

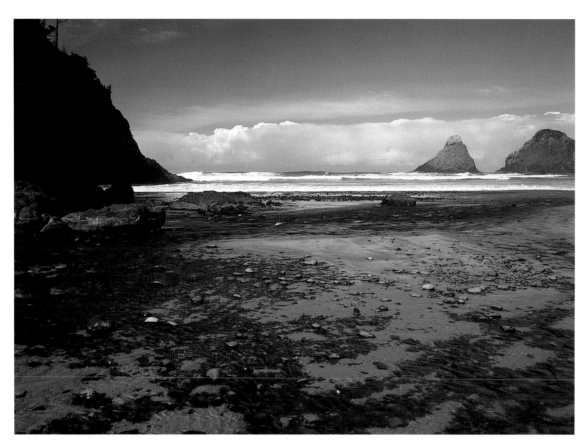

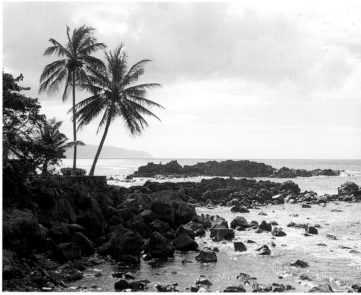

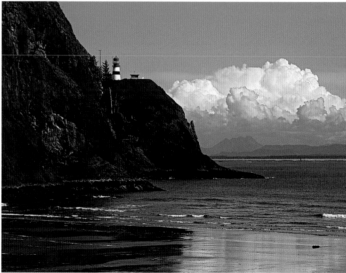

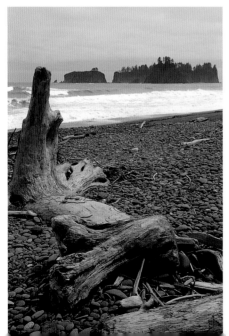

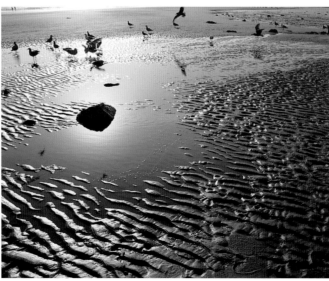

Lakes

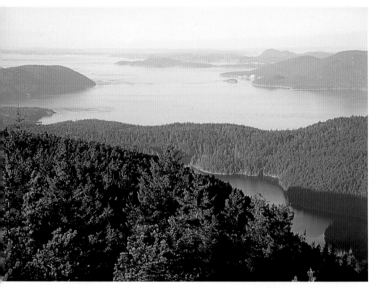

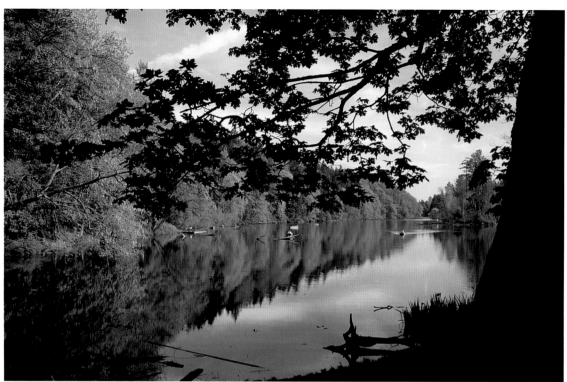

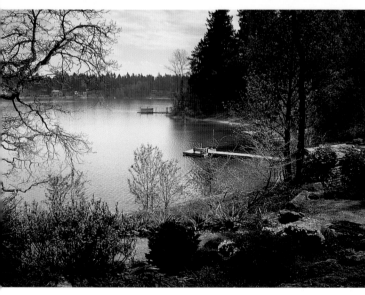

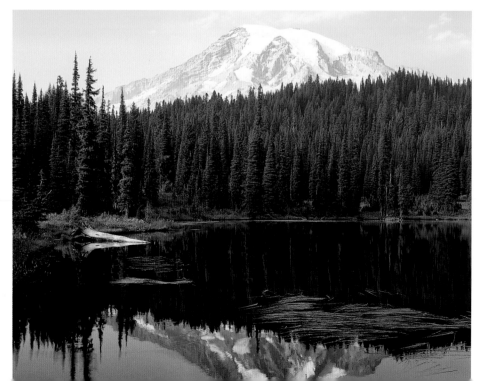

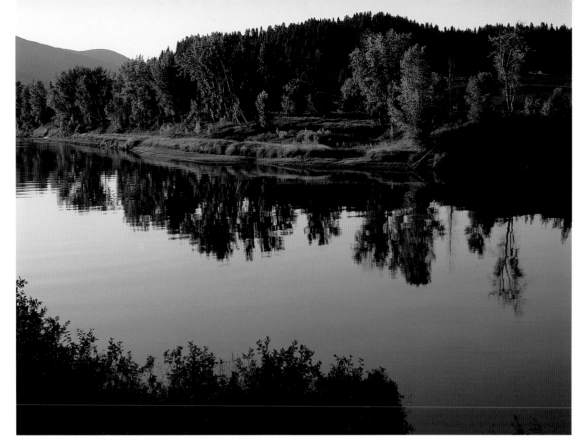

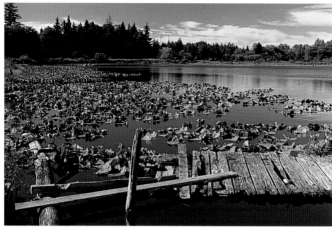

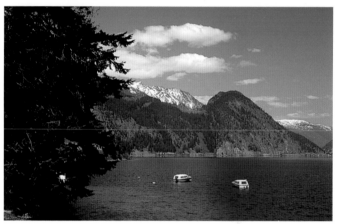

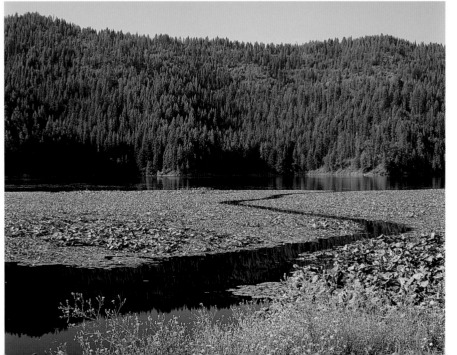

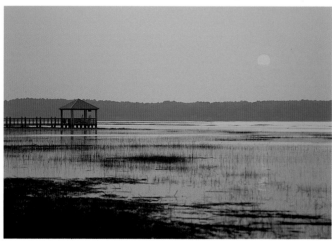

Ponds

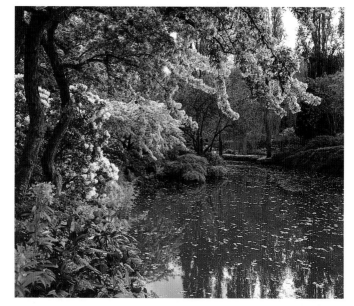

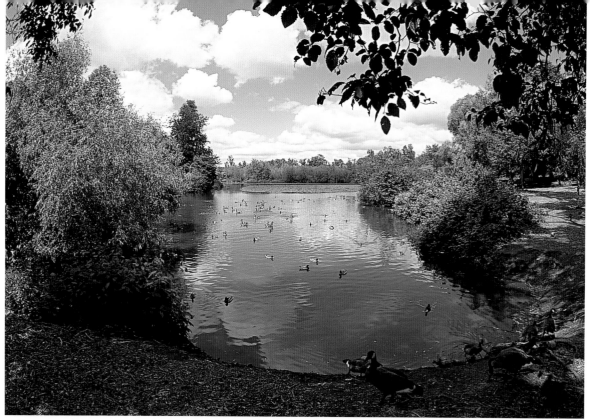

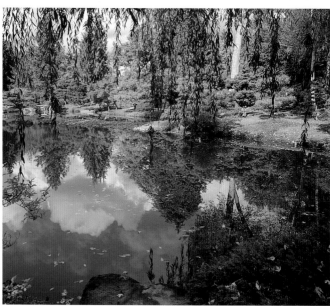

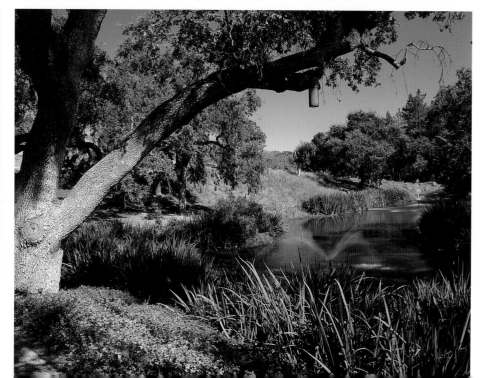

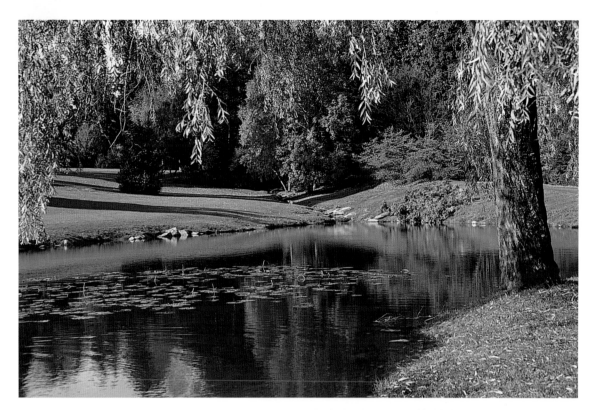
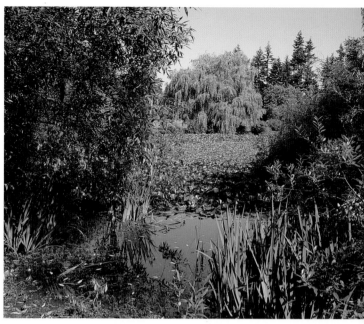

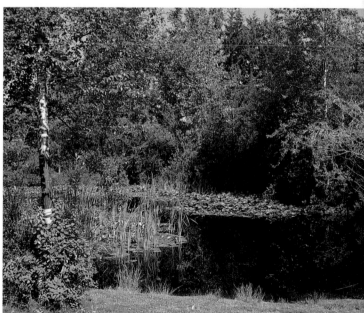

Rivers

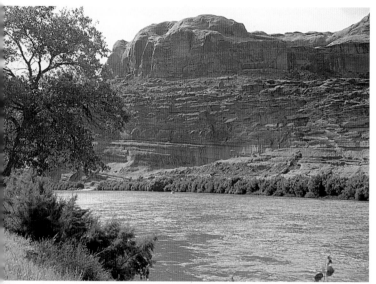

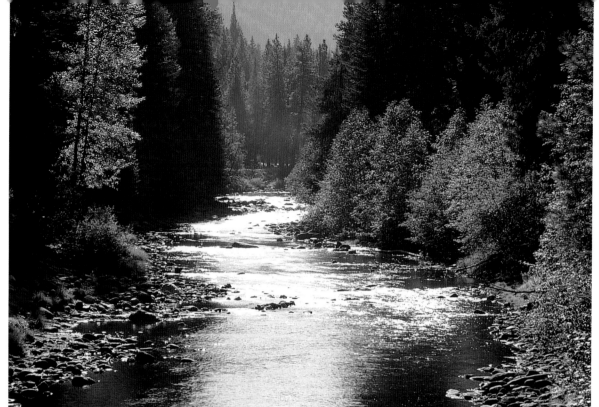

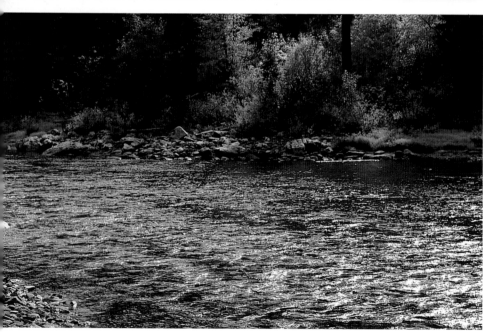

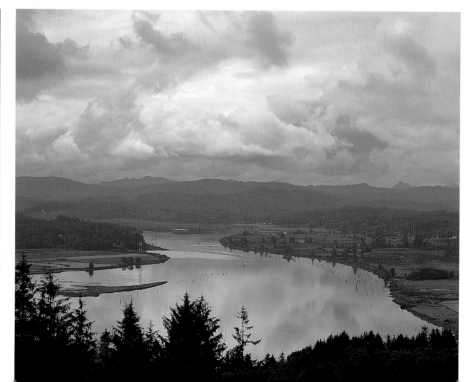

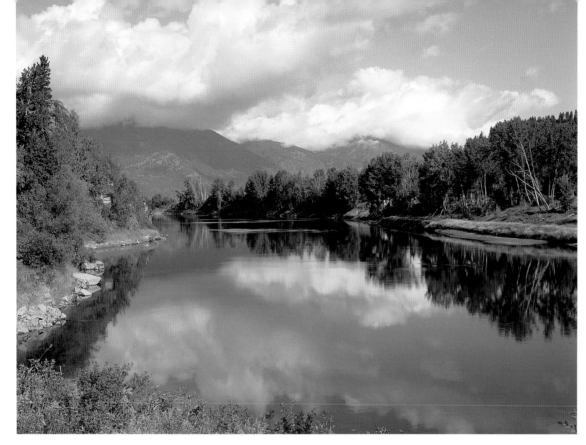

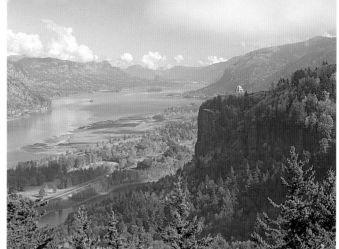

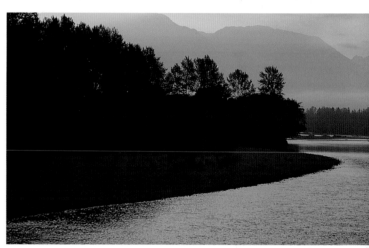

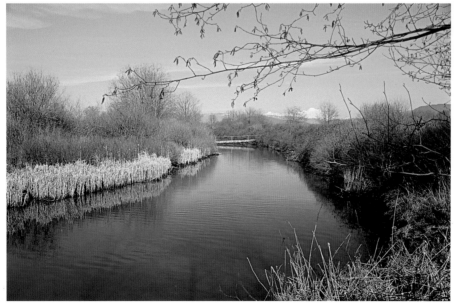

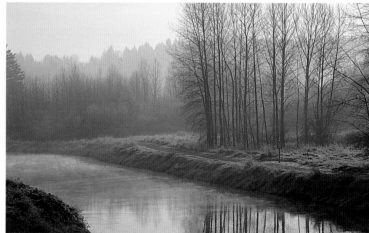

Streams

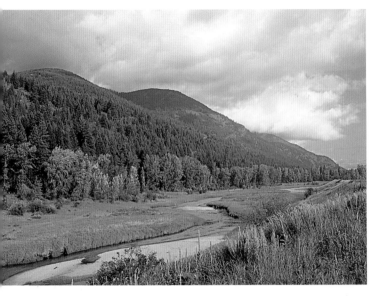

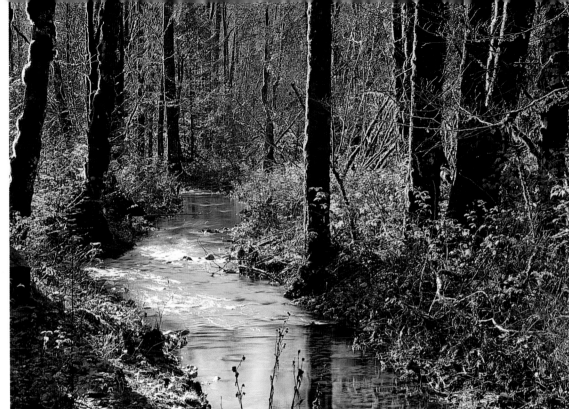

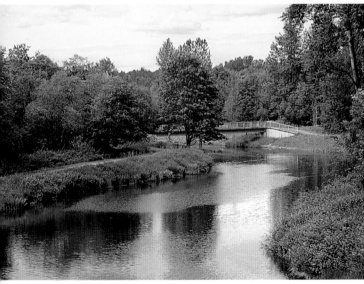

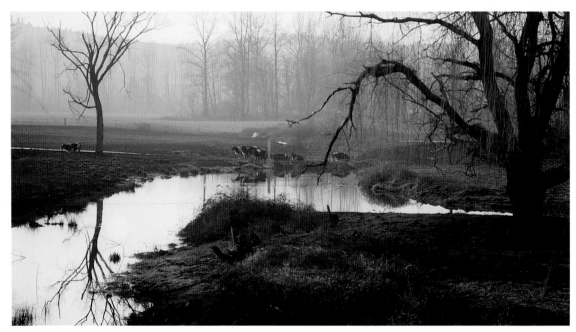

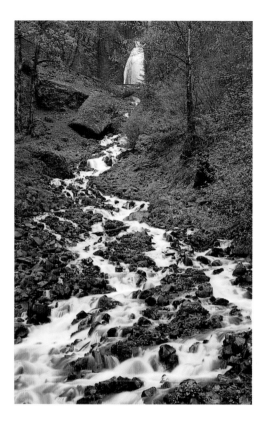

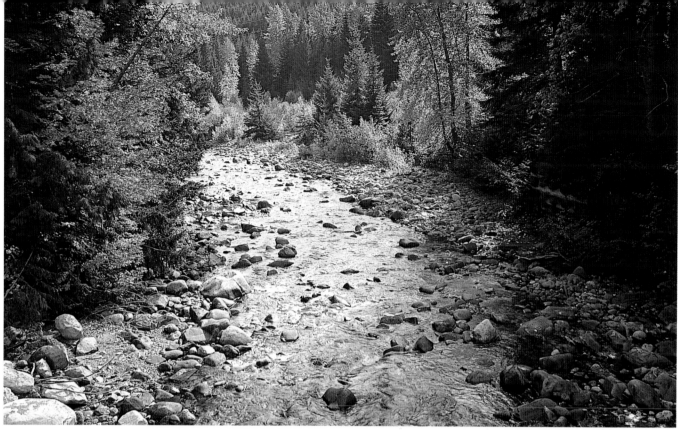

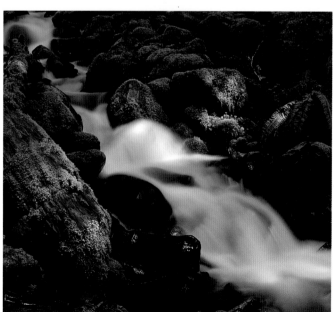

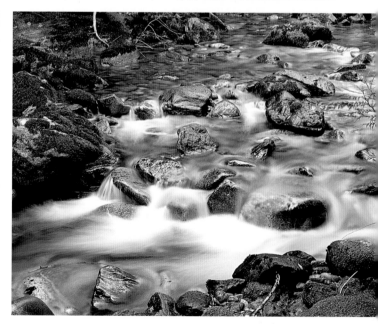

Falls

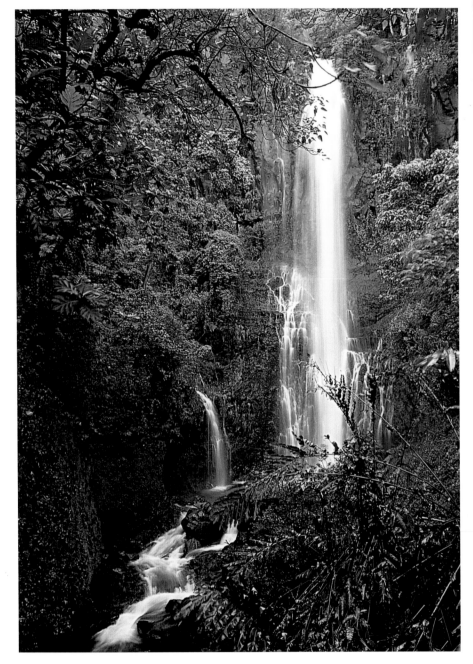

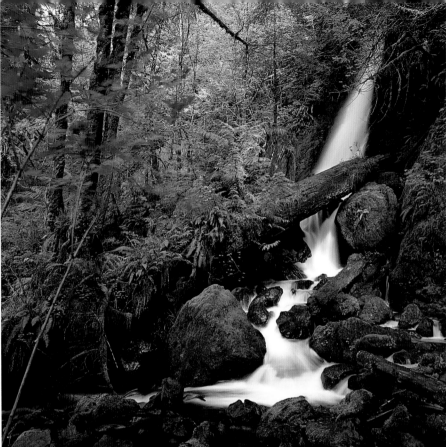

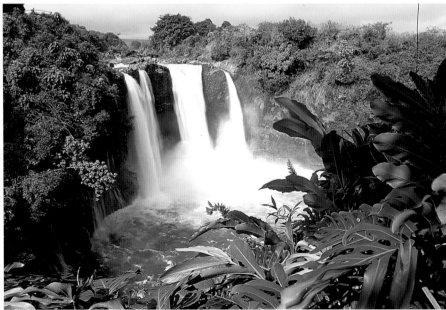

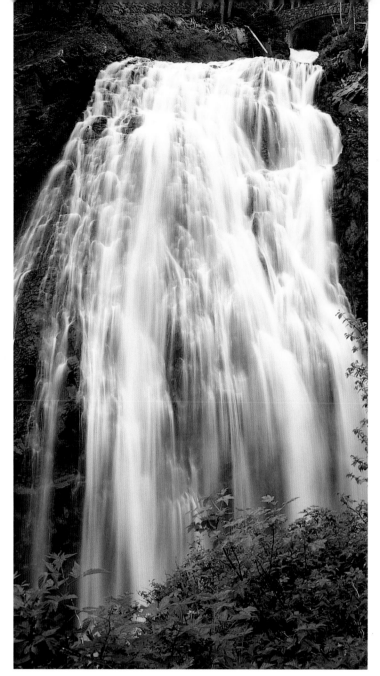
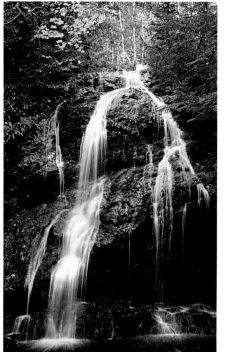
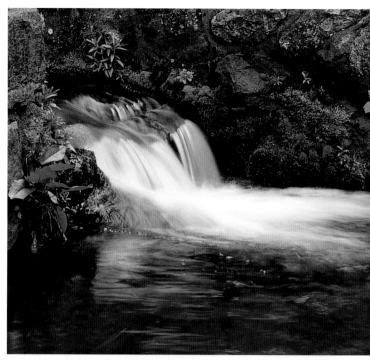
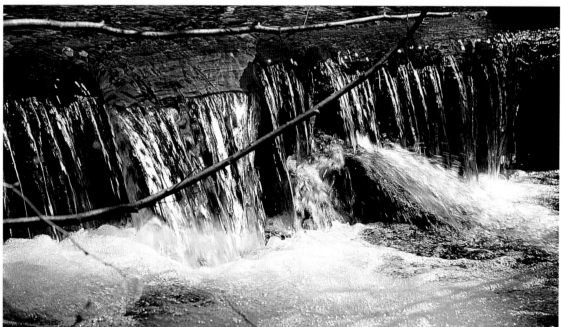

Rapids

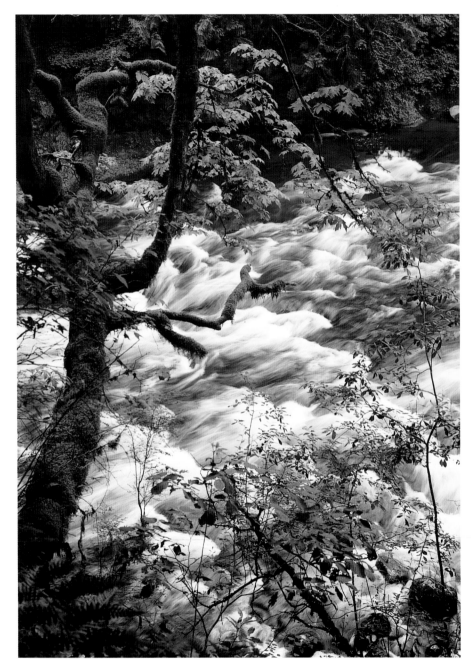

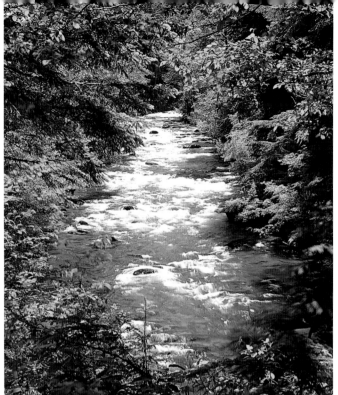

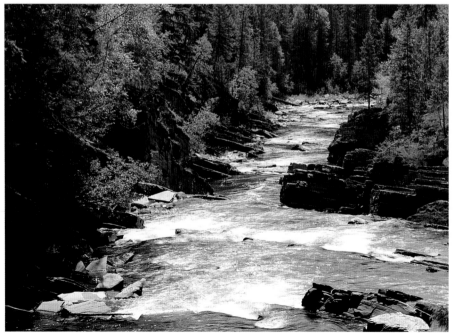

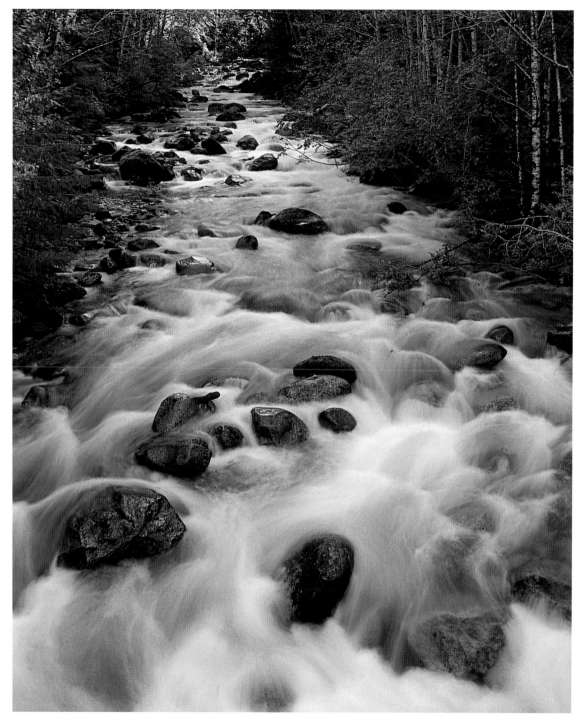
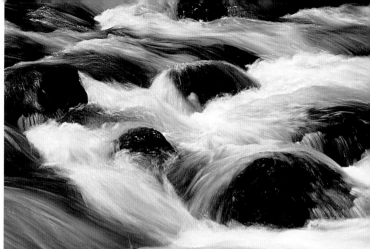
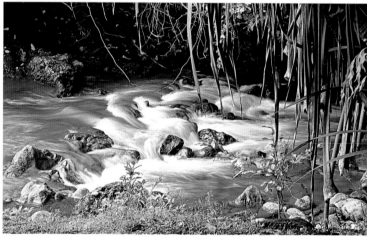
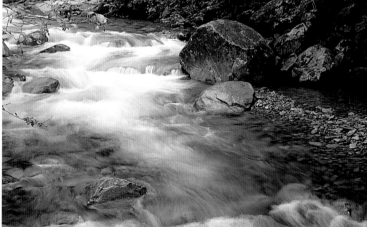

Rocky Stream in Colored Pencil

by Gary Greene

Materials

- half sheet of Arches 300-lb. (640gsm) rough watercolor paper
- 2B graphite pencil
- Kneaded eraser
- Electric eraser with Koh-I-Noor imbibed eraser strips
- Electric pencil sharpener
- Container for water
- Nos. 6 and 8 round watercolor brushes
- Paper towels
- Cotton swabs
- Small piece of sandpaper
- Hair dryer (optional)

Color Palette

Faber-Castell Albrecht Dürer water-soluble pencils—Brown Ochre, Burnt Carmine, Cream, Dark Orange, Dark Sepia, Gray Green, Indian Red, Ivory, Raw Umber, Terracotta, True Green, Van Dyke Brown, Venetian Red and Warm Gray I, II, III and IV

Faber-Castell Polychromos oil-based pencils—Brown Ochre, Burnt Carmine, Dark Sepia, Gray Green, Indian Red, Terracotta, True Green, Van Dyke Brown, Venetian Red, White and Warm Gray I, II and III

Winsor & Newton Derwent water-soluble pencils—Brown Ochre, Raw Sienna and Silver Gray

This painting demonstrates how selective cropping can enhance your composition. Although many interesting elements of the reference photo were cropped out, the finished painting offers a stronger composition. The reference photo was taken in the Mount Baker National Forest of Washington State. A slow shutter speed was used to depict the water's flow through the terra-cotta rocks.

This demonstration starts out using water-soluble colored pencils, with oil-based pencils used in the final step.

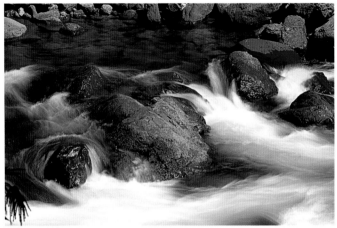

Reference photo

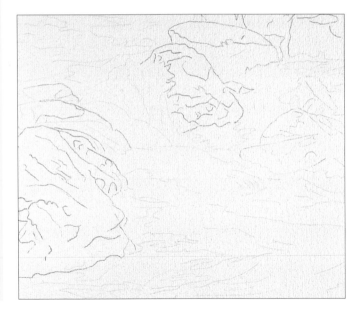

1. Lay Out the Composition

Lay out the painting on your watercolor paper with a 2B graphite pencil. When the composition is finalized, retrace it *next to* the graphite lines with the Silver Gray and Venetian Red water-soluble colored pencils. Then erase all the graphite lines with a kneaded eraser. The colored pencil lines will remain after erasing.

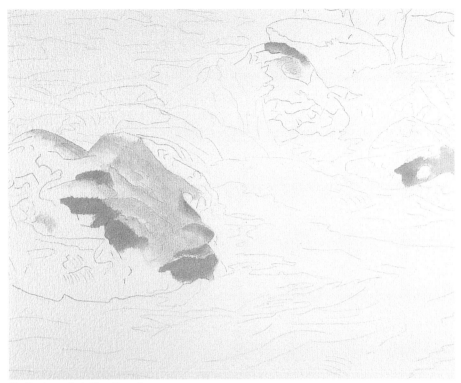

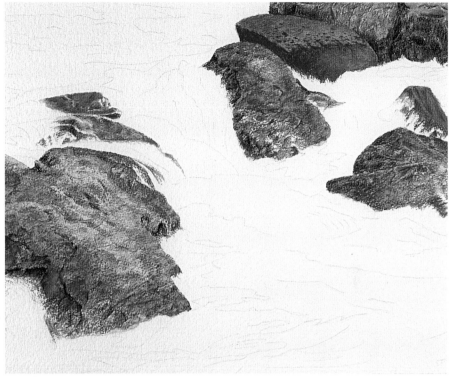

2. Underpaint the Fungi

Apply Raw Sienna, Cream and Ivory with a sharp pencil point to depict the light yellow fungi. Apply water with a medium-dry no. 8 round brush. Allow to dry thoroughly or dry with a hair dryer. Repeat the process with Terracotta, Dark Orange and Ivory to depict the orange fungi.

3. Paint the Rocks

Apply Warm Gray IV, Dark Sepia or Van Dyke Brown with a sharp pencil point to depict dark and shadow areas. Apply water with a medium-dry no. 8 round brush. Allow to dry thoroughly or use a hair dryer. Then apply various combinations of Indian Red, Venetian Red, Burnt Carmine, Brown Ochre (Faber-Castell) and Raw Umber to depict the rocks. Leave some areas clear of pigment for water or highlights.

4. Paint the Water

Underpaint the still water areas with light applications of Gray Green and True Green. Apply water with a medium-dry no. 8 round brush. Allow to dry thoroughly or use a hair dryer.

Next paint submerged rocks and other underwater features on top of the green underpainting by applying various combinations of Dark Sepia, Van Dyke Brown, Raw Umber, Raw Sienna and Brown Ochre (Winsor & Newton). Apply water with a medium-dry no. 6 or no. 8 round brush. Dry thoroughly with a hair dryer or allow to air dry.

To depict the rapid water, lightly apply Gray Green, True Green and Warm Gray I, II or III. Apply water with a medium-dry no. 8 round brush. Dry thoroughly with a hair dryer or allow to air dry.

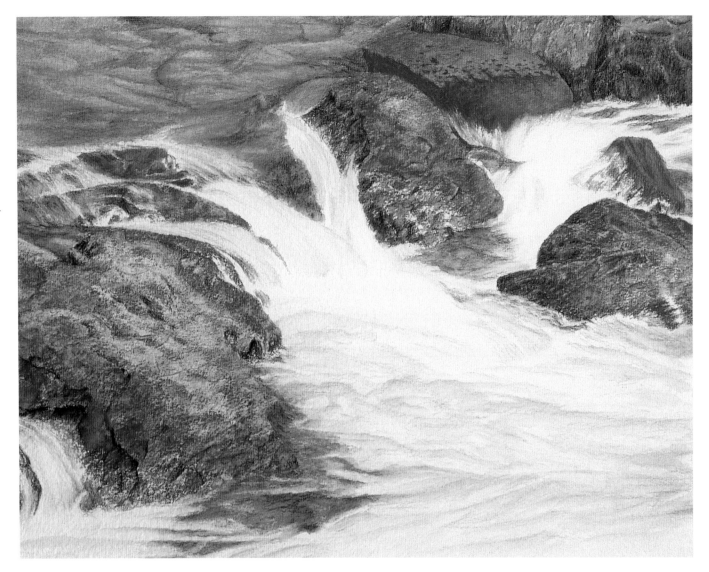

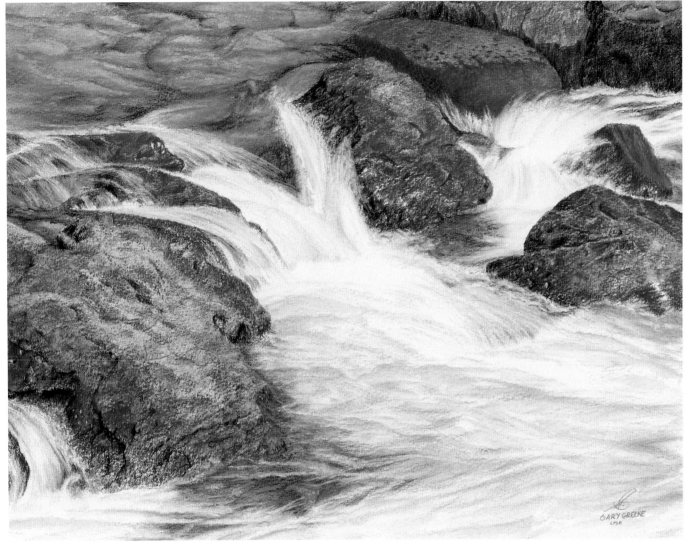

5. Tie Rocks and Water Together

Using medium pencil pressure, add details to areas with darkest values with Polychromos oil-based pencils Dark Sepia and Van Dyke Brown. Tighten areas where water contacts the rocks by adding applicable rock and water colors, including Polychromos True Green, Brown Ochre, Burnt Carmine and Terracotta. Enhance the rapid water by lightly adding Polychromos Gray Green and Warm Gray I, II or III, then blending with a dry cotton swab. Repeat as necessary.

Using very light pencil pressure, add half-immersed rocks with various combinations of Polychromos Indian Red, Venetian Red, Dark Sepia and Van Dyke Brown. Sharpen the end of a vinyl electric eraser strip to a point with a small piece of sandpaper. Lightly erase areas where the water meets the base of the rocks and waterfalls to create a fine-mist effect. (Frequently sharpen the eraser point.) Lightly reapply applicable rock colors (Brown Ochre, Burnt Carmine and Terracotta). Add strokes of Polychromos White to depict waterfall details over the rocks.

Water on the Rocks
GARY GREENE
10½" x 14½" (27cm x 37cm)

Keep Pencils Sharp

The "dry" colored pencils in the final step must be kept extremely sharp at all times. Due to the rough texture of the paper, the point dulls quickly, requiring frequent sharpening.

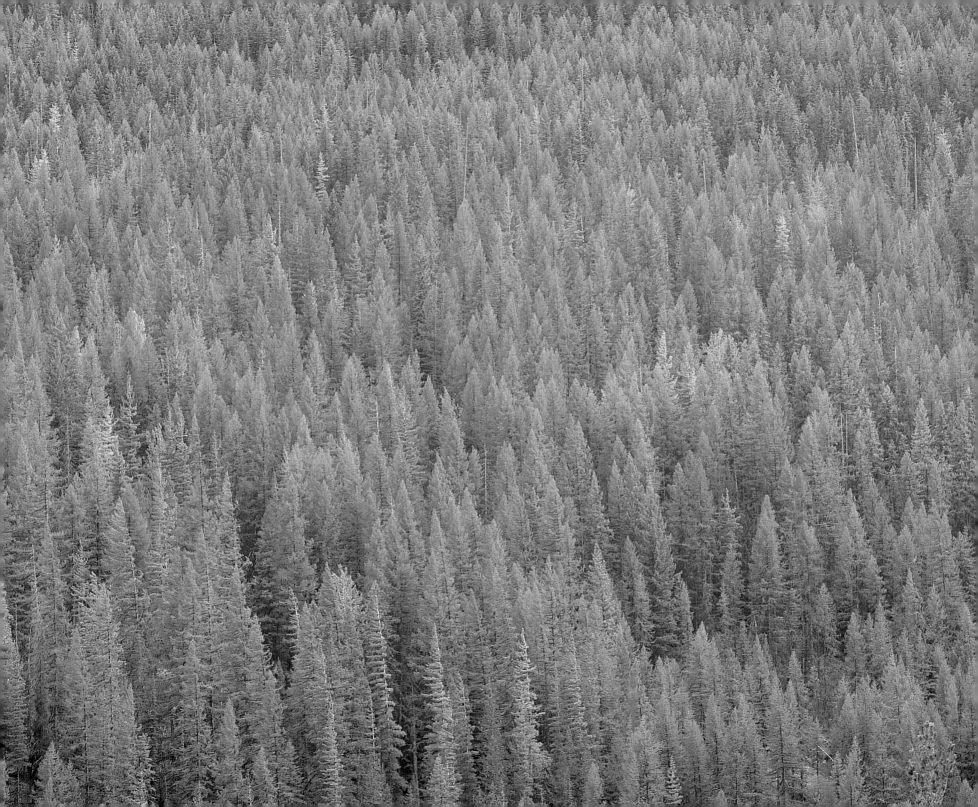

Trees

A tree can be the focus of a painting,

or a cluster of them may supplement a composition.

Here are examples of both coniferous and deciduous trees,

as well as tropical and bare trees.

Coniferous

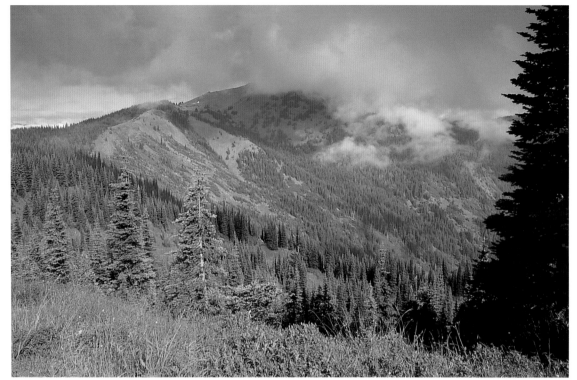

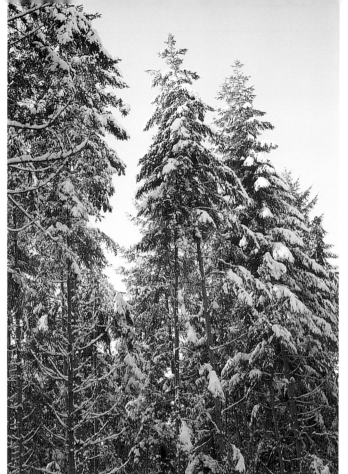

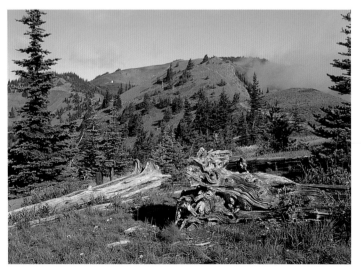

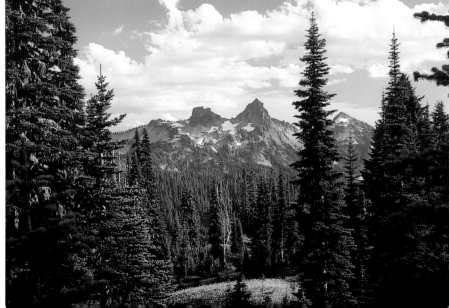

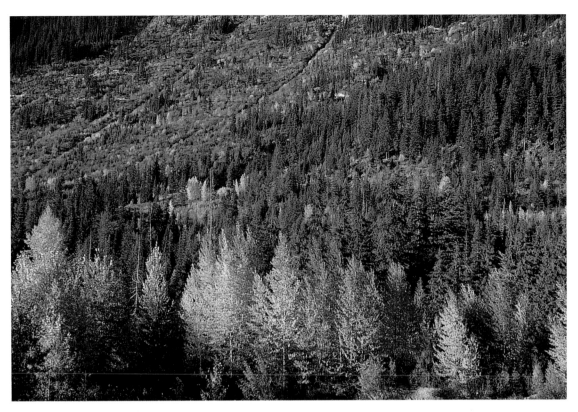

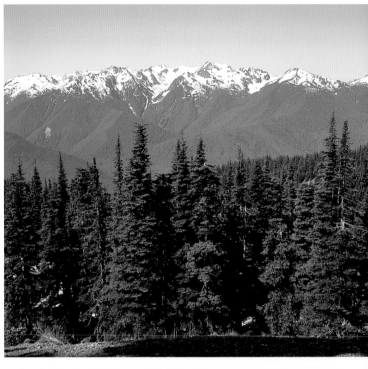

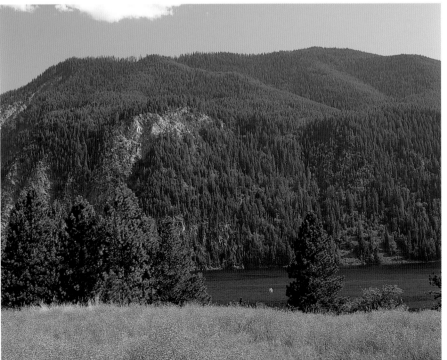

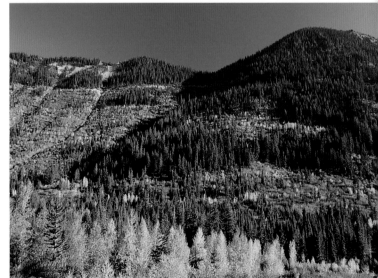

Deciduous

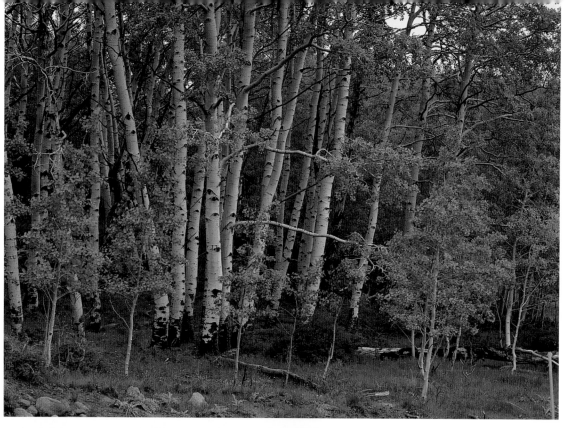

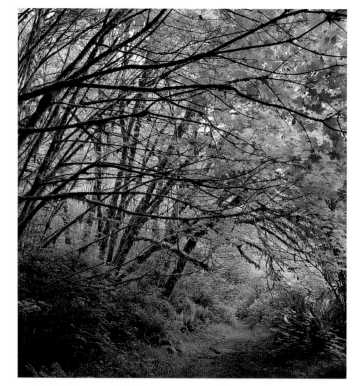

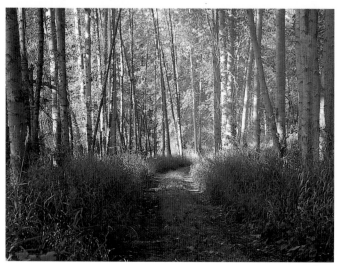

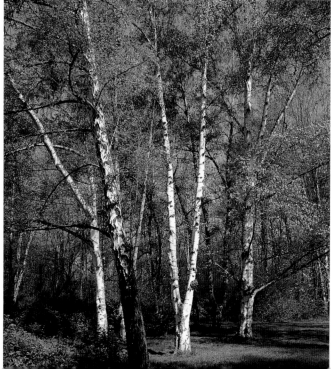

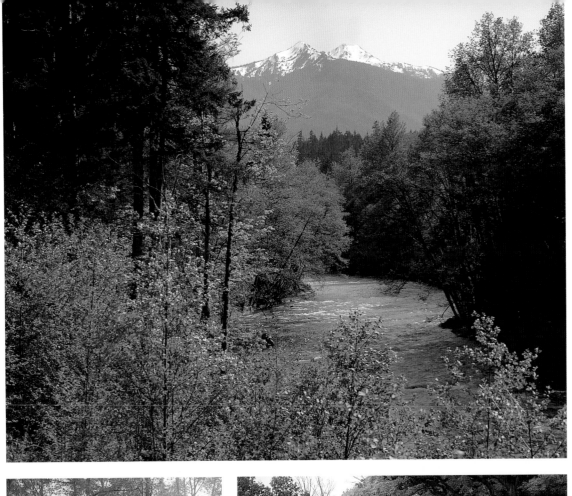
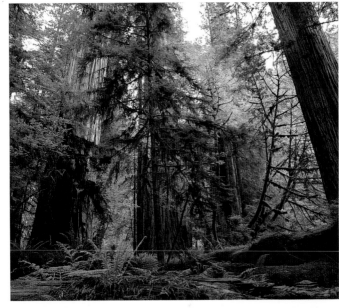

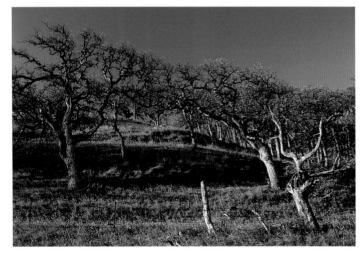

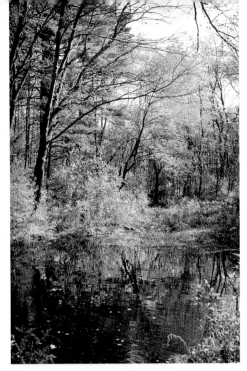

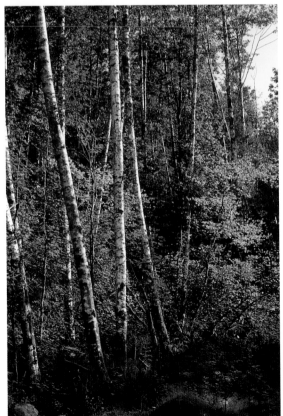

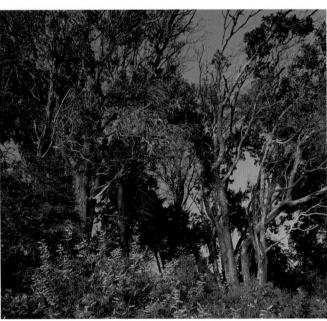

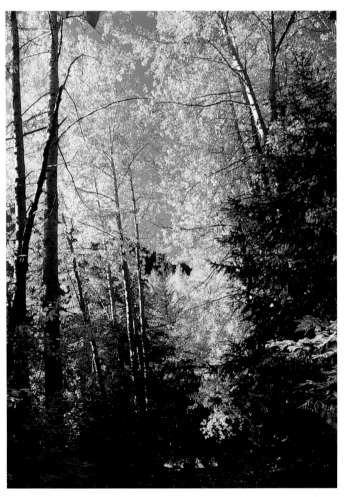

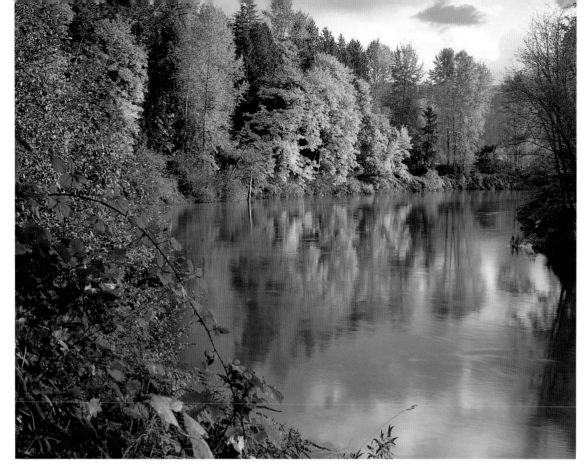

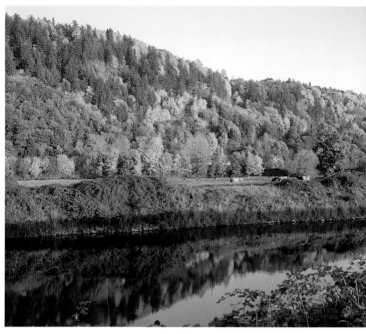

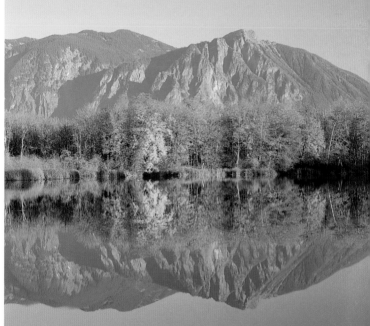

Tropical

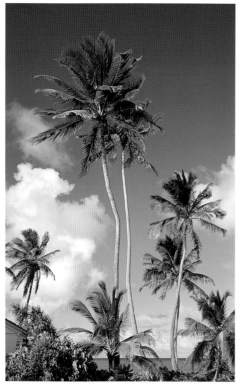

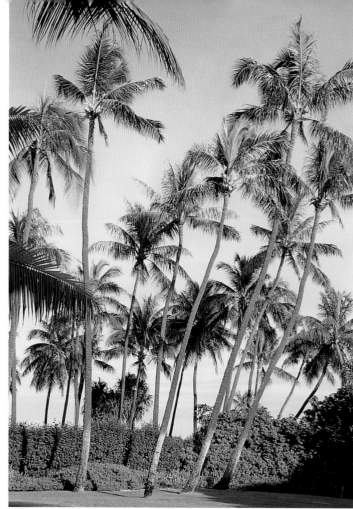

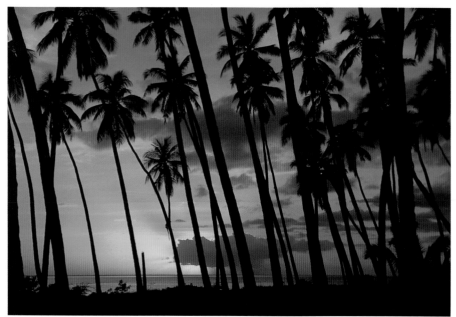

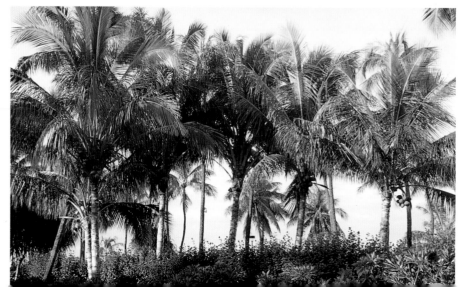

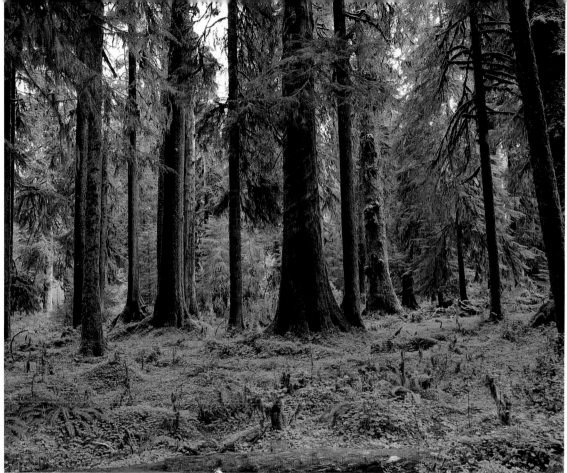

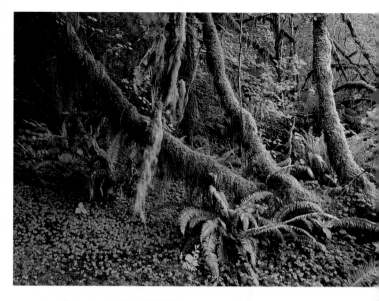

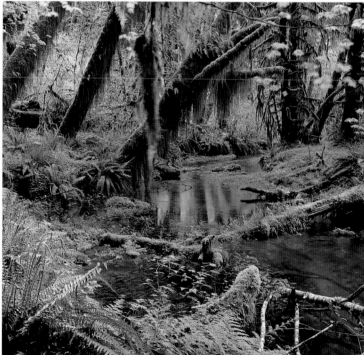

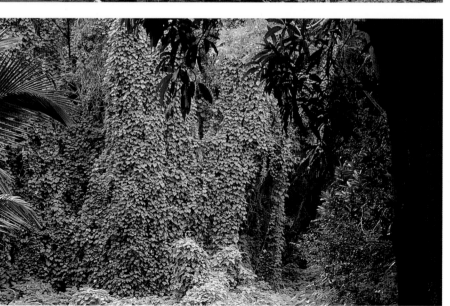

Bare

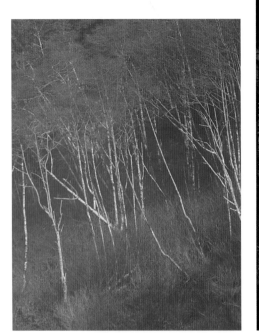

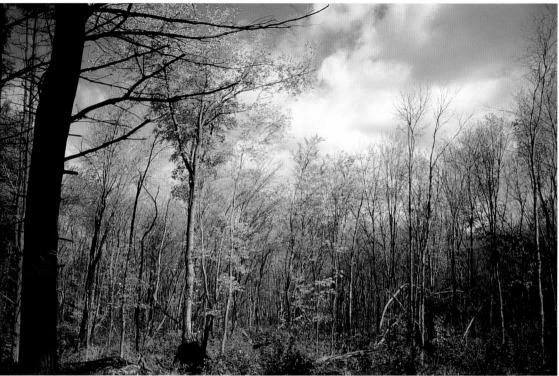

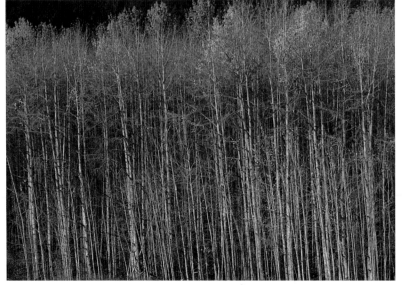

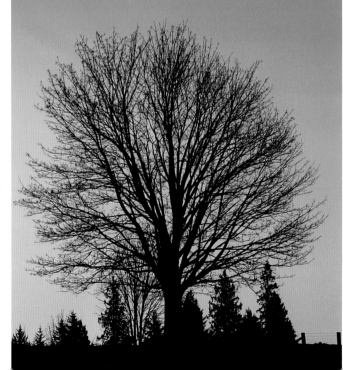

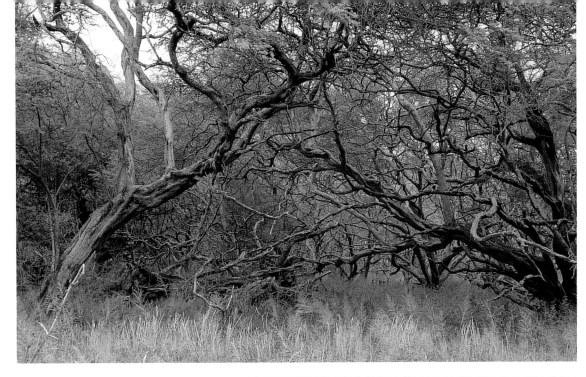

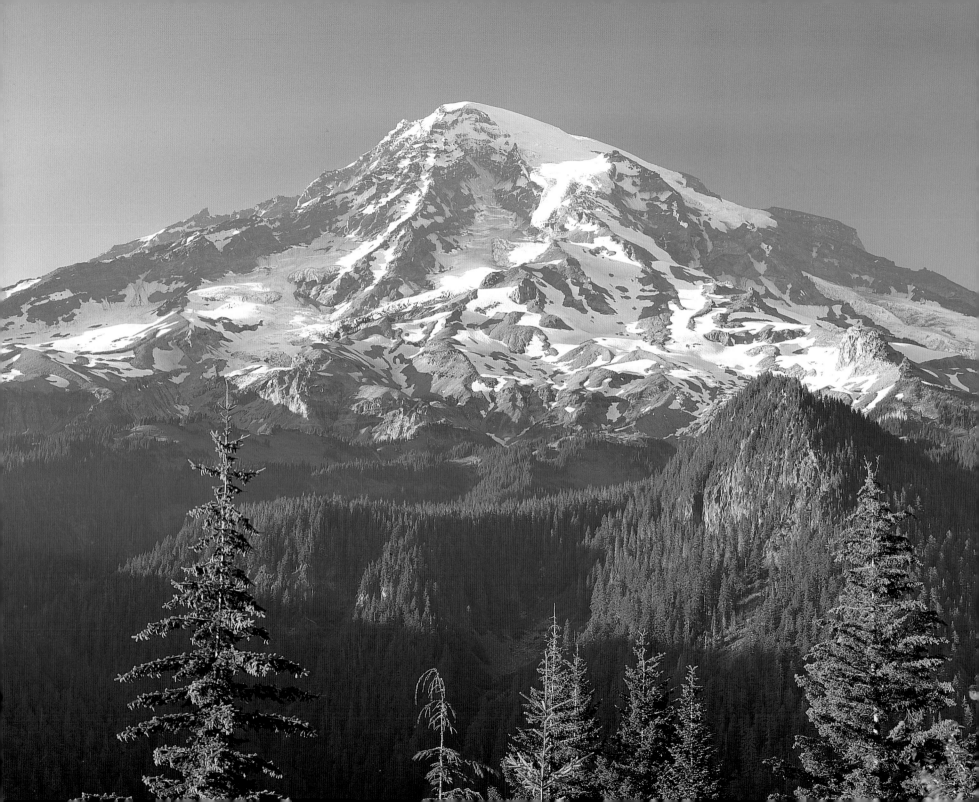

Mountains, Hills and Rocks

Mountains with and without snow, close-up and in the distance,

plus a variety of hills are pictured in this section.

The rock photos offer a wide range of textures, colors and

lighting to help you create convincing rocks in your paintings.

Mountains

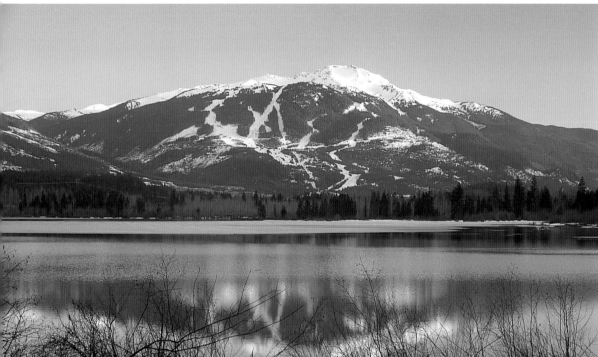

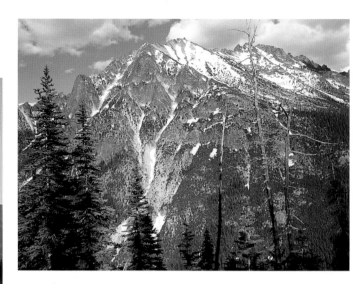

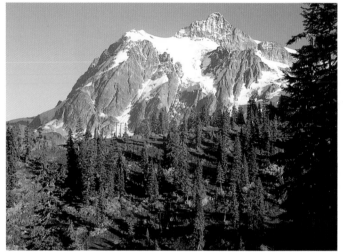

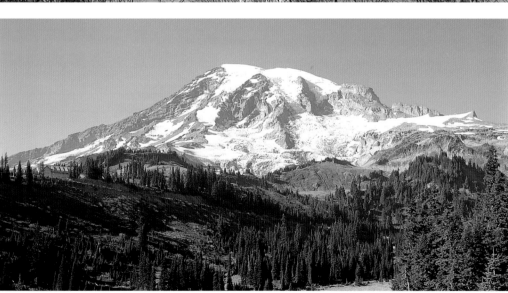

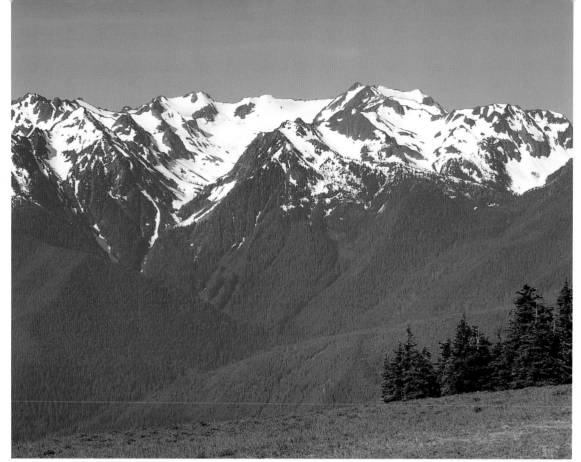

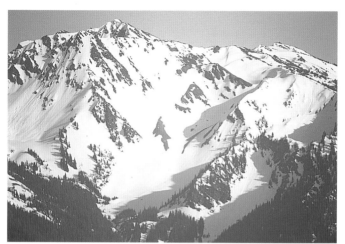

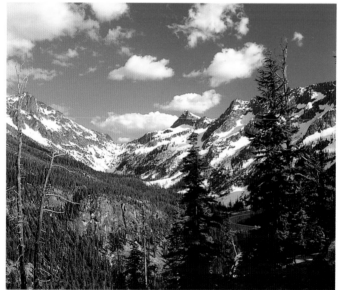

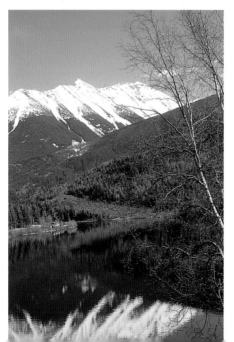

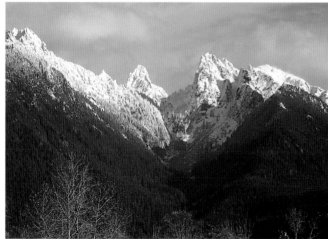

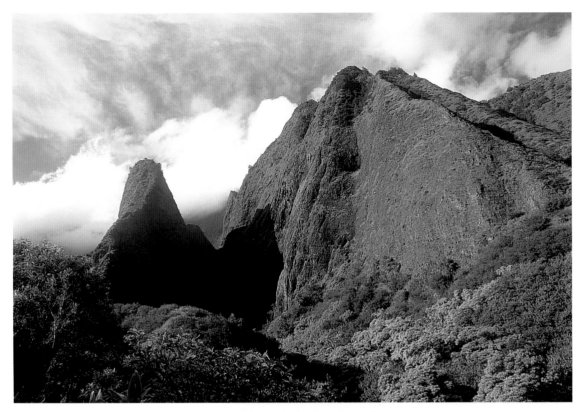

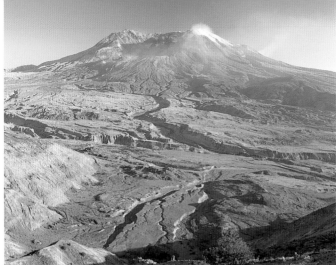

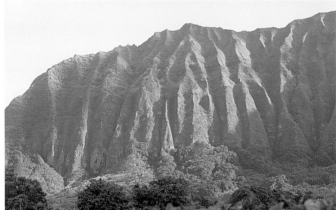

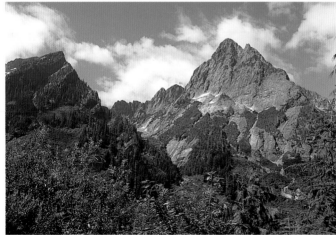

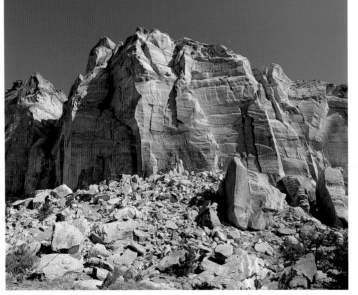

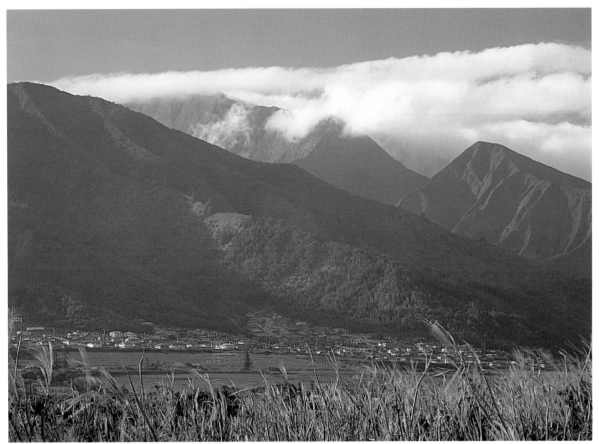

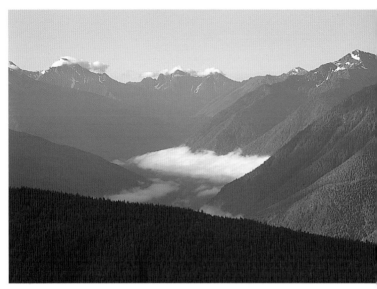

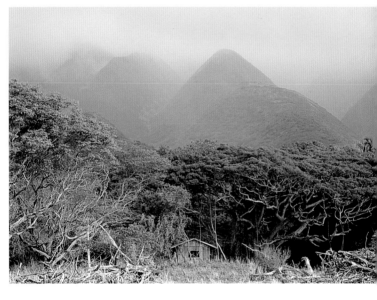

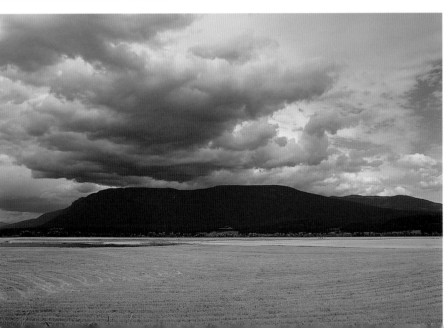

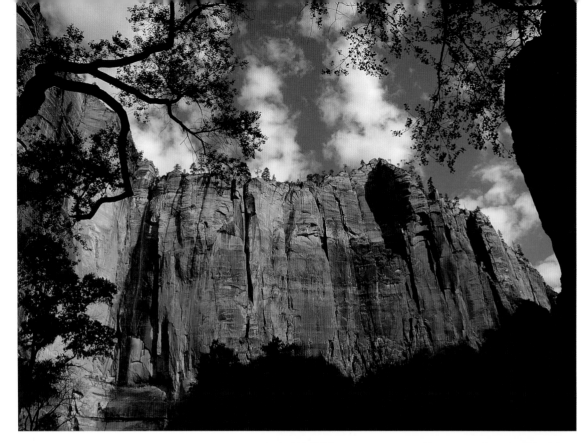

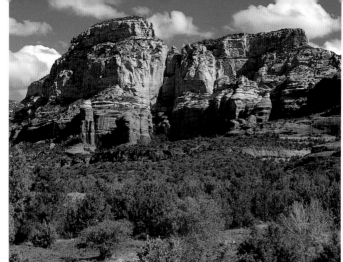

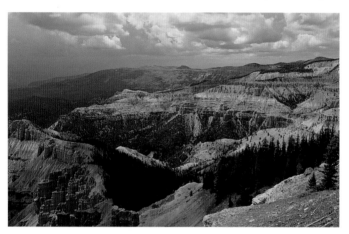

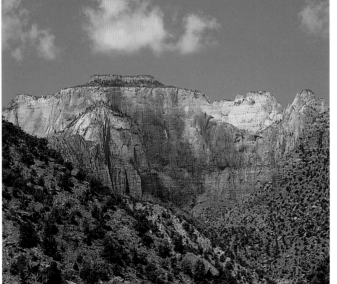

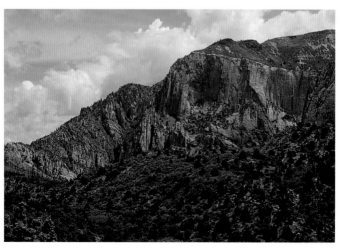

Hills

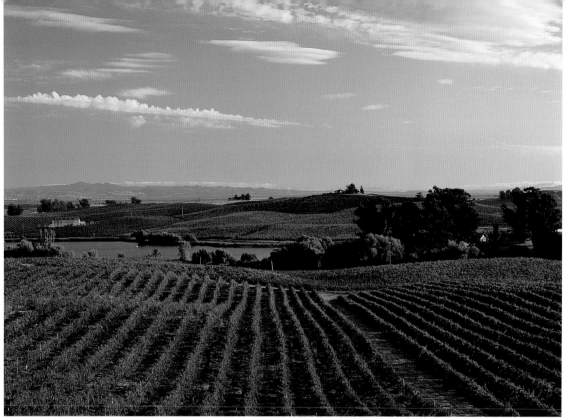

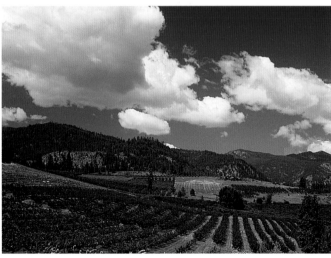

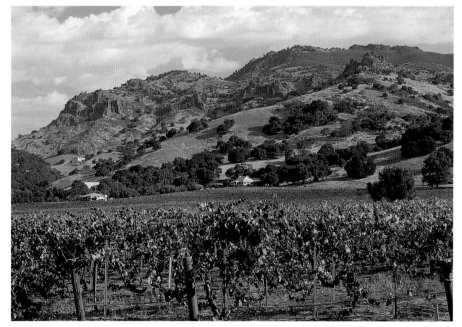

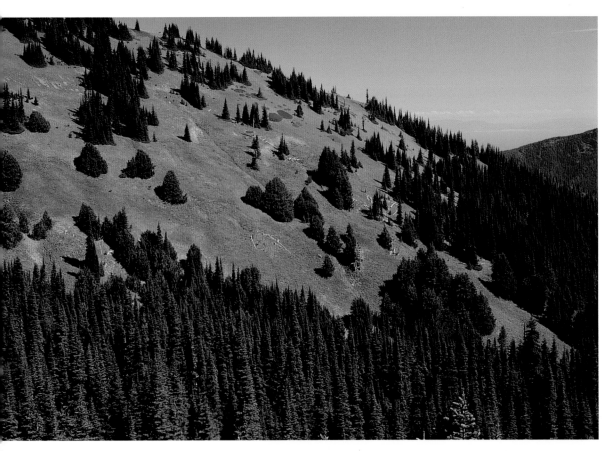

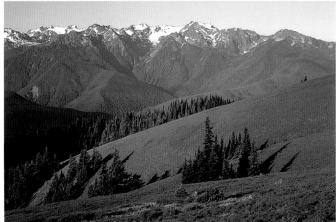

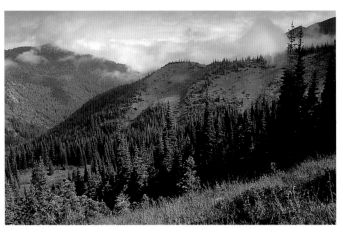

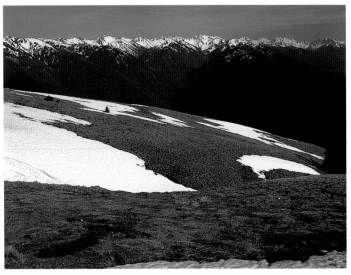

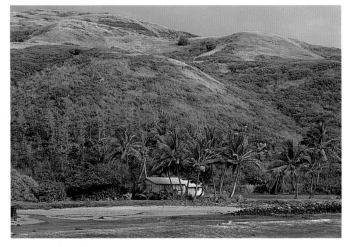

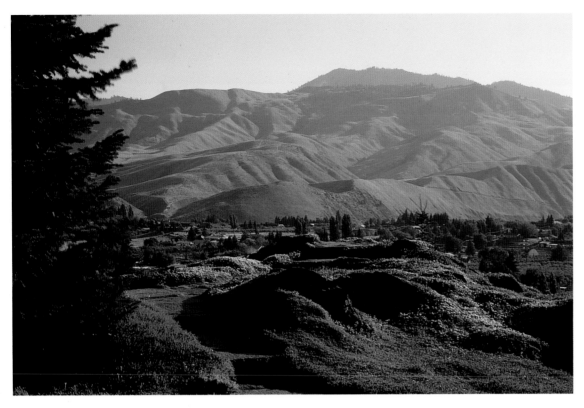

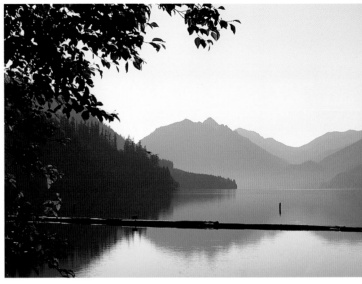

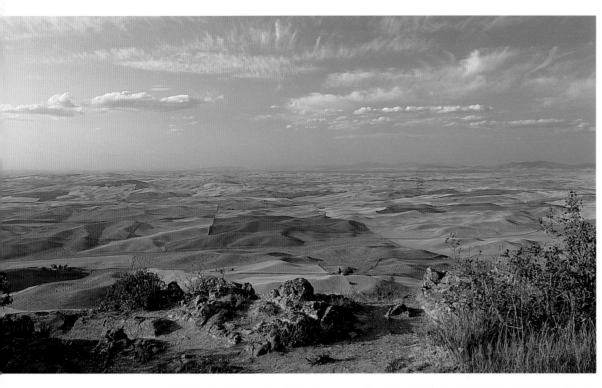

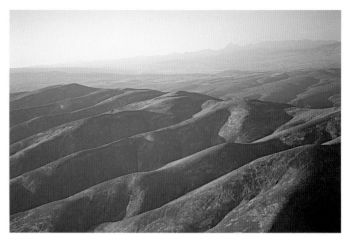

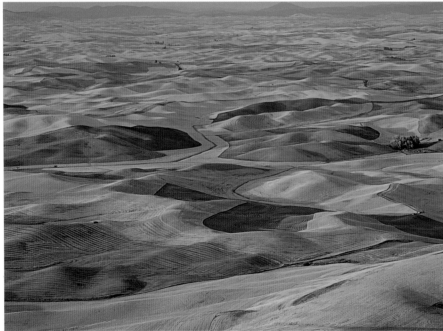

Rocks

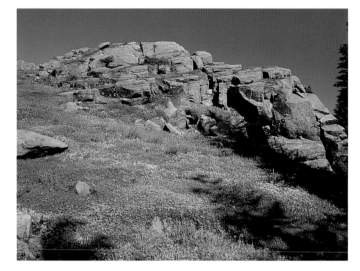

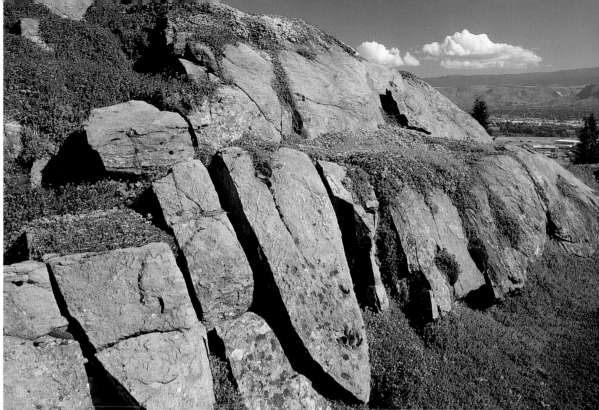

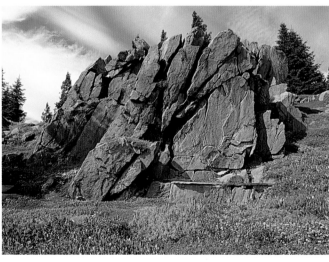

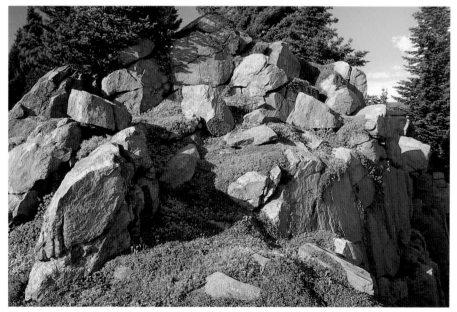

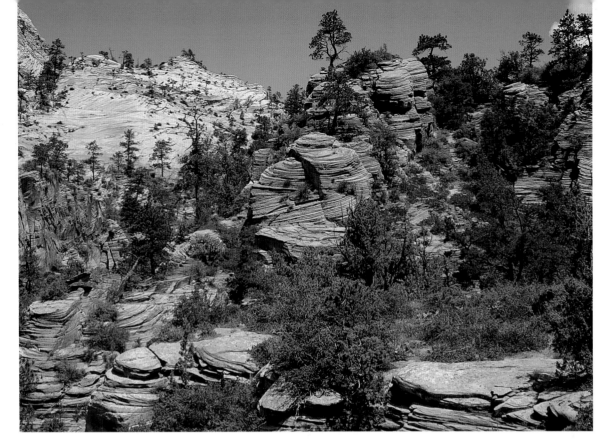

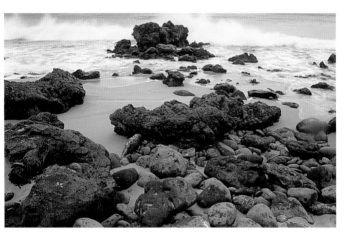

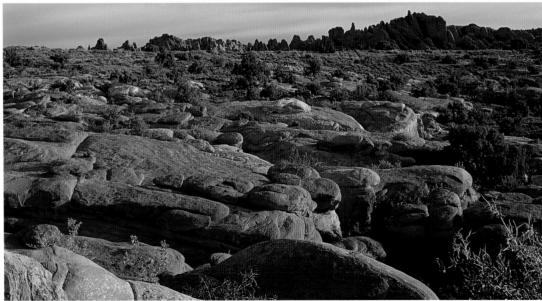

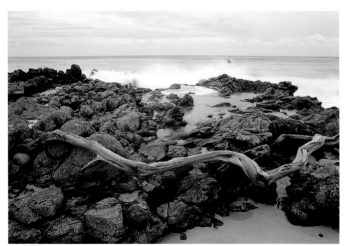

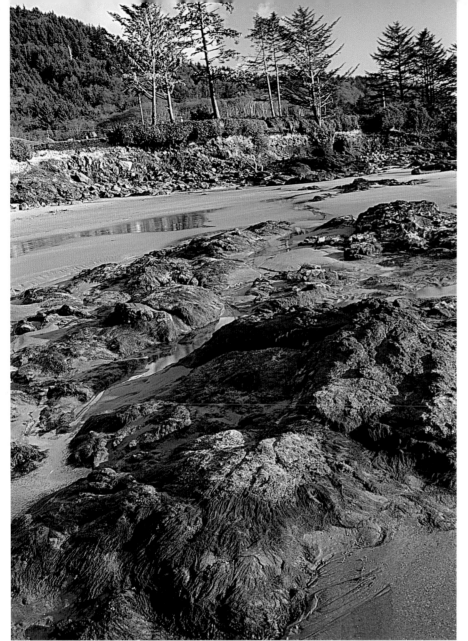

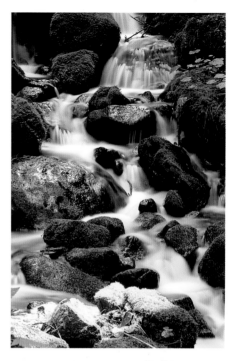
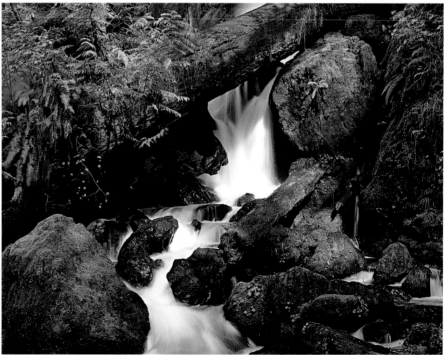

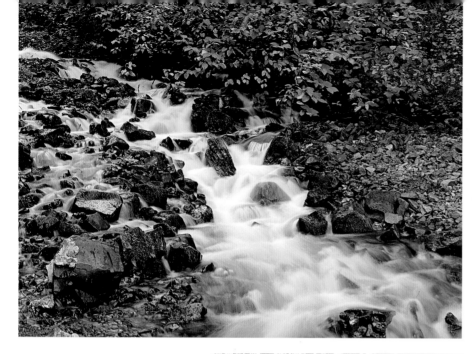

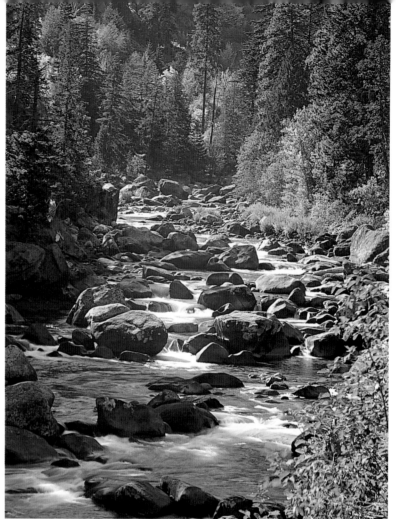

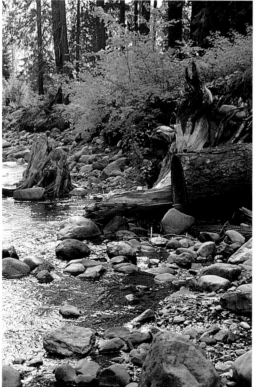

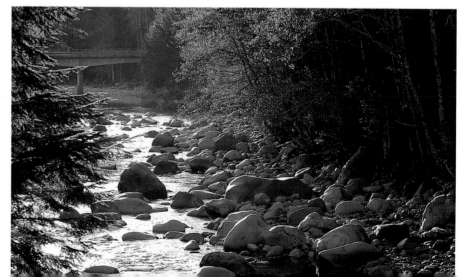

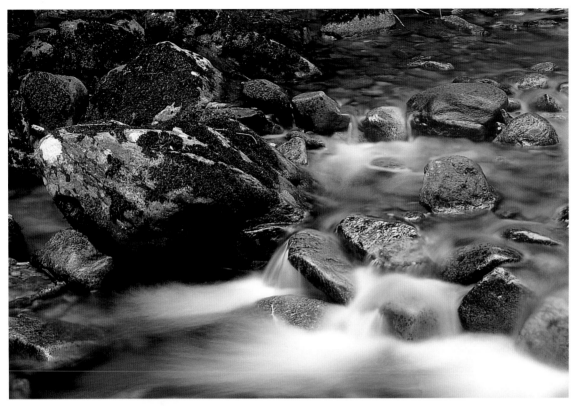

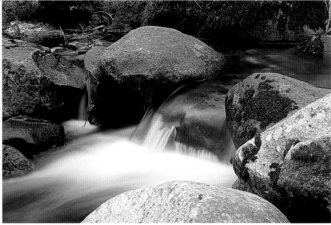

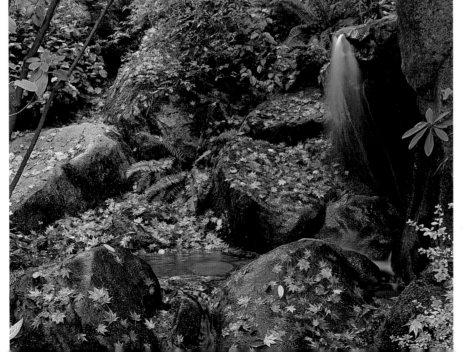

by Mary Sweet

Sandstone Rock Structures in Acrylic

Materials

18" x 24" (46cm x 61cm) 300-lb. (640gsm) hot-press watercolor paper

No. 2 graphite pencil

Paper palettes

Enamel trays (for covering palettes when not in use)

Spray bottle (for keeping paint moist)

Empty peanut cans (for mixing/storing larger quantities of paint)

No. 18 Langnickel round watercolor brush

Old splayed no. 8 brushes (for mixing paint)

Nos. 1, 2, 4, 6 and 8 watercolor brushes

Color Palette

Liquitex Tube Acrylics—Acra Violet, Burnt Sienna, Burnt Umber, Cadmium Orange, Cadmium Yellow Medium, Cerulean Blue, Chromium Oxide Green, Dioxazine Purple, Mars Black, Payne's Gray, Permanent Hooker's Green, Permanent Hooker's Green Deep, Phthalo Blue, Red Oxide, Titanium White, Ultramarine Blue, Yellow Ochre, Yellow Oxide, Yellow Orange Azo, Unbleached Titanium

Mary Sweet, an accomplished Southwest artist, is intimately familiar with the remarkable terrain of this area. Her unique stylistic rendition of sandstone structures referred to as "hoodoos" evokes an ethereal feeling all its own.

The primary reference photograph (below) was taken at Red Rock Canyon State Park, just a few miles from spectacular Bryce Canyon National Park in Utah. A polarizing filter was used to enhance the colors in the scene, then the painting was further enhanced by adding fleecy cirrus clouds that were photographed an entire region away in the Pacific Northwest (photo at right).

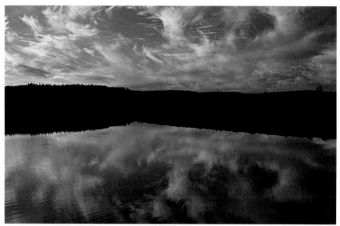

Reference photos

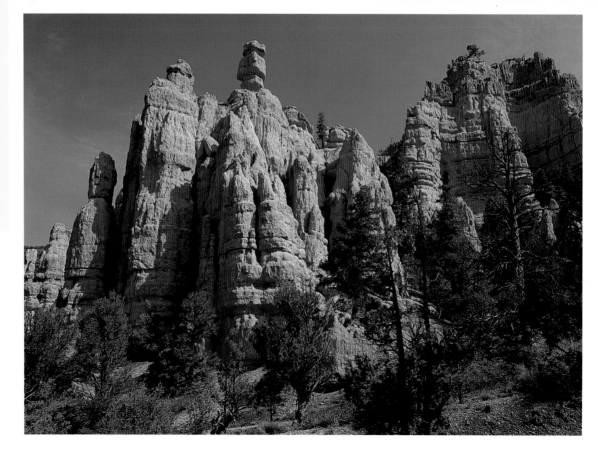

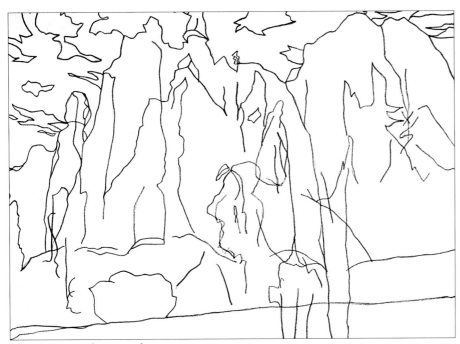

1. Make Your Line Drawing

Very lightly draw the main shapes of the rocks and clouds with a no. 2 graphite pencil on untreated watercolor paper. The drawing shown here is actually darker than yours should be; it was done this way so you could see the lines more clearly. I usually just block in main shapes and not details, since I'd just paint over them anyway when painting the underlying shapes.

Turn Paper for Easier Painting
When painting freehand, turn the paper as needed to work from the angles that are easiest for you.

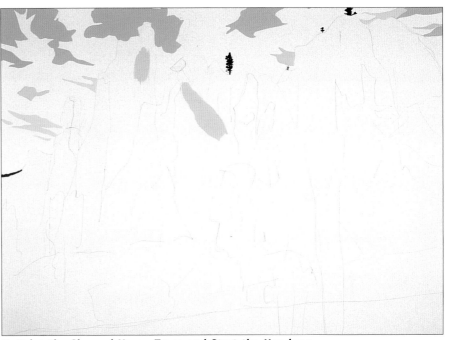

2. Paint the Sky and Upper Trees and Start the Hoodoos

On a paper palette, mix Titanium White from the tube with enough water so it will spread. With the no. 18 round brush, cover the entire sky area with Titanium White. Be sure to cover any pencil lines. Mix Phthalo Blue, Ultramarine Blue and Titanium White for the blue sky patches. Use the no. 8 brush to mix and fill in the big areas and a no. 4 brush for the tighter ones. (You may have to mix paint more than once to achieve the right color, smoothness and texture.) Directly on the canvas, paint a mixture of Titanium White, Cerulean Blue and Payne's Gray for the few grayer shapes on the cirrus clouds. Keep the paint even and smooth.

Mix a large amount of Cadmium Yellow Medium, Titanium White, Yellow Oxide and Yellow Orange Azo and paint the main cliffs of the hoodoos. (Use a washed, empty peanut can to store the paint so you can go back to it later.)

Paint the tiny trees on top of the hoodoos using Permanent Hooker's Green, Burnt Umber and Dioxazine Purple with the no. 4 and no. 2 brushes. (Use the smaller brushes for second coats.) Add highlights with a mixture of green and Yellow Oxide using a no. 1 brush. Use Payne's Gray for the branches.

3. Shape the Rocks

Begin shaping the rock formations by painting the large rock shapes with the yellow mixture from the peanut can using the no. 18 round brush for the large areas, the nos. 8, 4 and 2 brushes for the smaller areas. Mix Cadmium Orange and Titanium White and put in patches on the lighter rocks. Detail areas as you go. For instance, at the top right of the rocks, mix Titanium White, Dioxazine Purple, Red Oxide and Burnt Umber (start the foreground with these colors, too). Use variations created with Payne's Gray for some patches and add detail using Yellow Ochre and Titanium White, Red Oxide, Cadmium Orange and Burnt Umber.

4. Shade and Detail the Rocks

Add subtle color differences to the orange in the rocks. Use Dioxazine Purple and Burnt Umber for the darkest darks in the cracks and to help define form. For slightly lighter darks, add Burnt Sienna and a bit of Titanium White. The hoodoos are very complex; work from left to right across the paper, defining form with dark color variations and adding details as you go. Mix Acra Violet and Titanium White with the dark residue on your brush. Add some of this color in areas where the spires have eroded to the ground, and in a few small patches higher on the rocks. For the hoodoos on the right, use oranges, Unbleached Titanium and mixtures of Burnt Sienna, Burnt Umber, Red Oxide and Titanium White. Use the no. 2 brush for the small details and nos. 4 and 6 for the larger ones.

Painting With Acrylics

When painting with acrylics, you may need to paint an area more than once as some colors are translucent and do not cover completely.

5. Add Lower Trees and Complete the Foreground

Now mix Chromium Oxide Green with Mars Black, Unbleached Titanium and Titanium White in various combinations to create lighter and darker variations of greens to paint some of the trees and bushes. Use brush nos. 6 and 8.

The rock walls have been painted in behind the tree areas. You will have to work back and forth between the greens and the oranges to show the cliffs through the leaves. In the foreground, put in oranges and grayed purples interspersed with green and gray-green bushes and grasses, using the no. 2 and no. 4 brushes. Use Payne's Gray, Titanium White and a tiny bit of Chromium Oxide Green for the light gray-green areas. The brighter greens are Chromium Oxide Green mixed with Yellow Oxide and Titanium White.

Add the darker green shadow areas in the trees using Permanent Hooker's Green and Permanent Hooker's Green Deep. Finally, add the tree trunks and branches using a no. 1 brush. Most are Mars Black, but some trunks are mixtures of Burnt Umber, Titanium White and Burnt Sienna.

To finish, look carefully at the painting to see if anything is needed or if anything is out of balance. For example, I decided to add some small stones in the foreground of this painting. Usually, I find that if each part of the painting works with the previously painted area, there are very few corrections to make at the end.

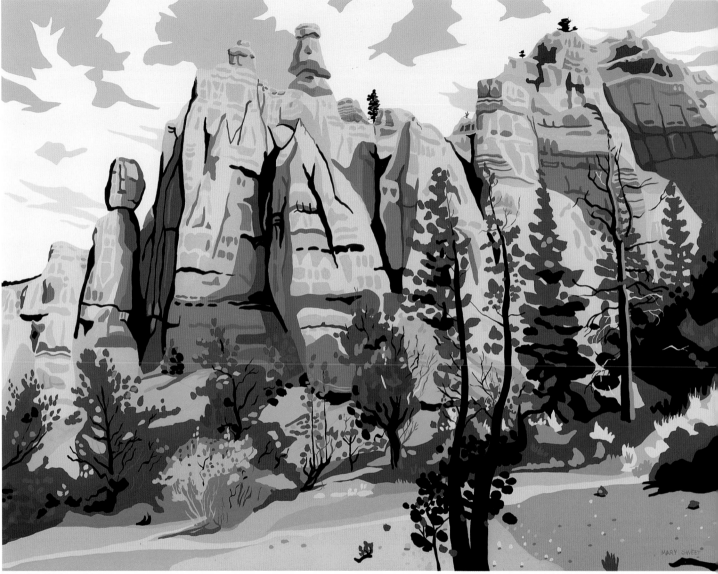

Song of the Sandstone Spires

MARY SWEET

18" x 24" (46cm x 61cm)

Deserts

Many artists don't have the opportunity to visit desert environs

to take reference photos, so here's the next best thing:

a section showing desert elements of all kinds including

rock formations, dunes and cacti.

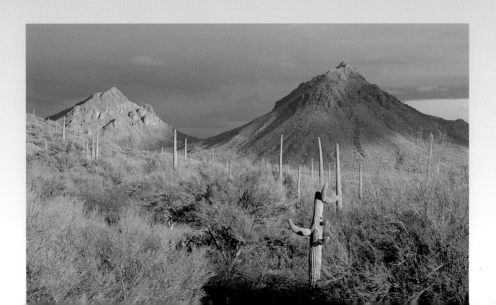

Terrain

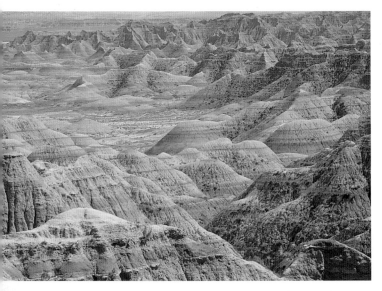

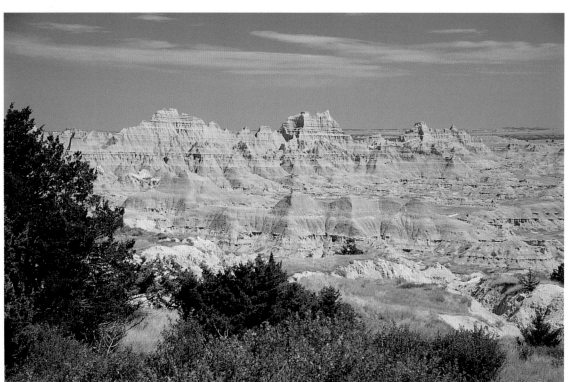

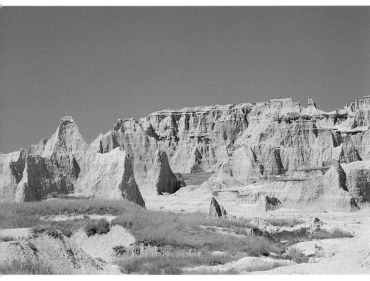

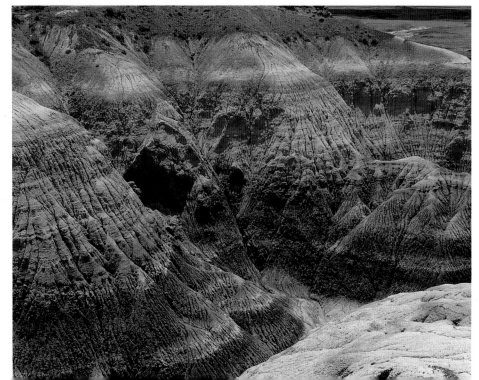

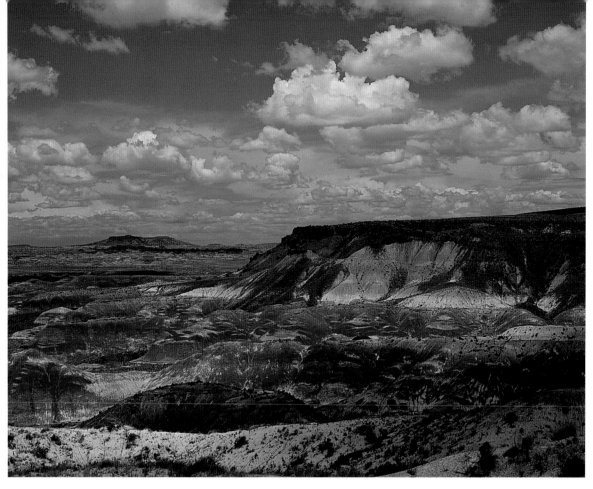

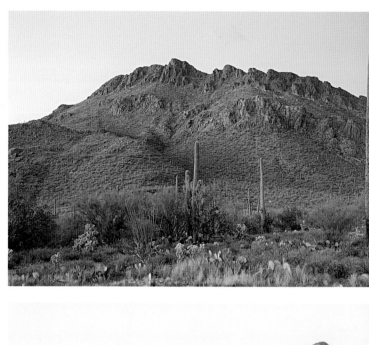

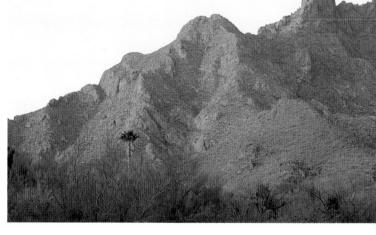

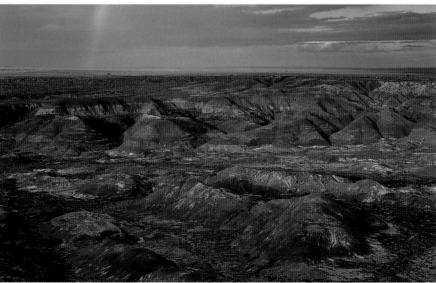

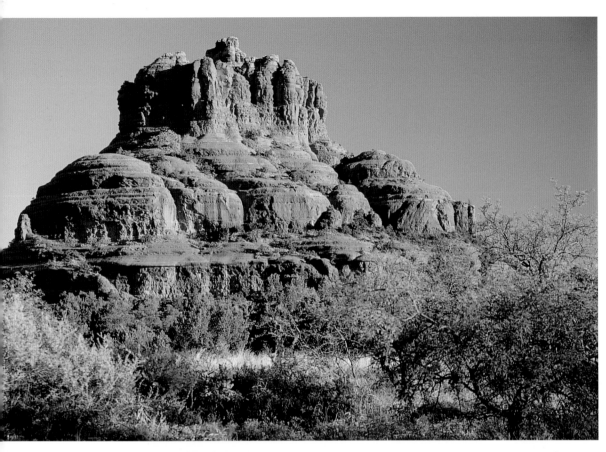

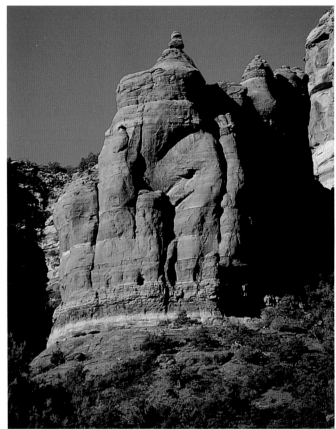

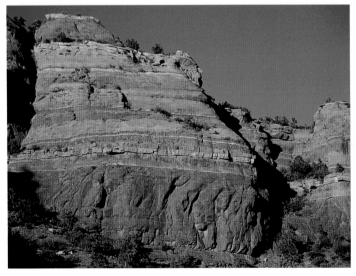

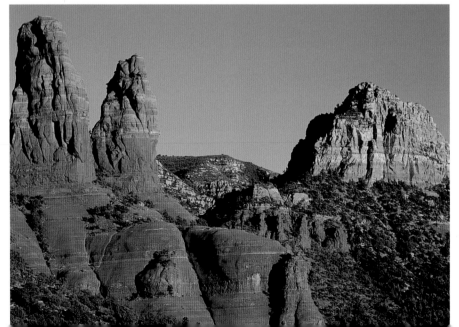

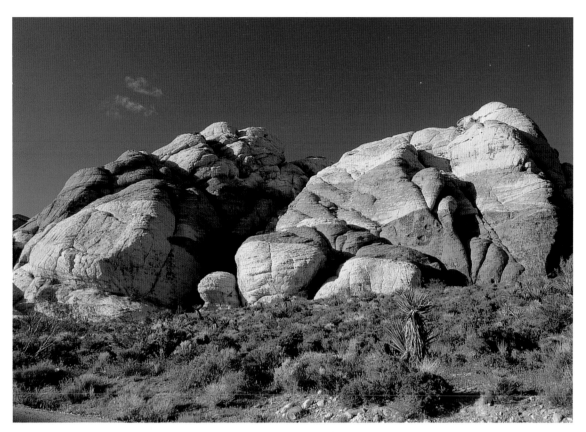

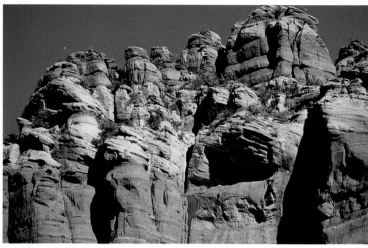

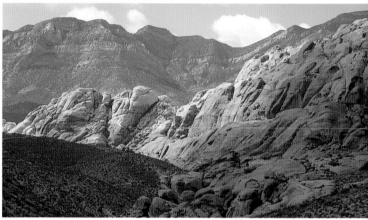

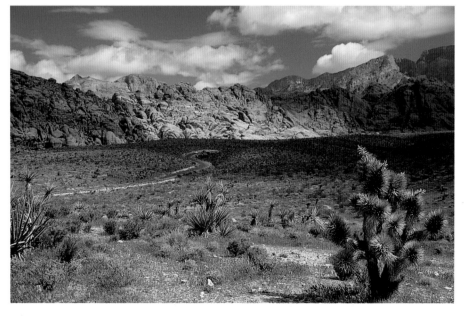

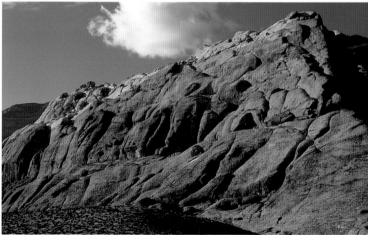

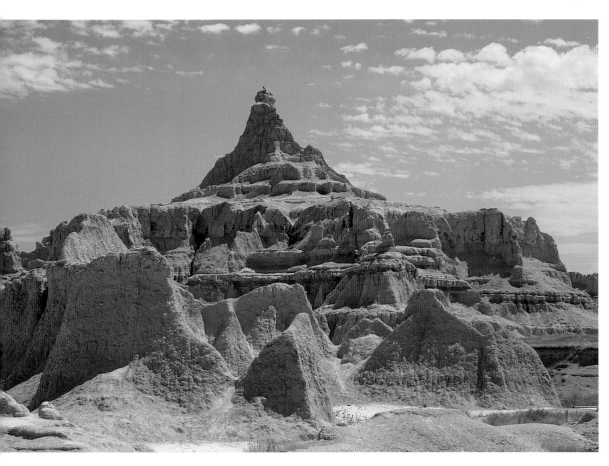

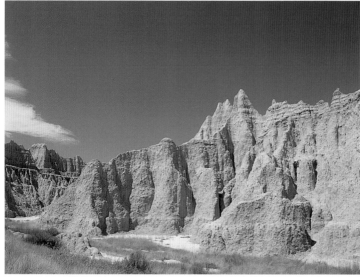

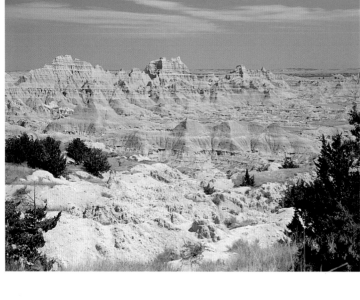

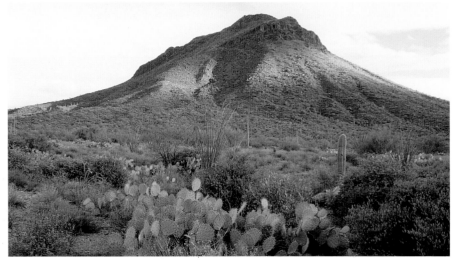

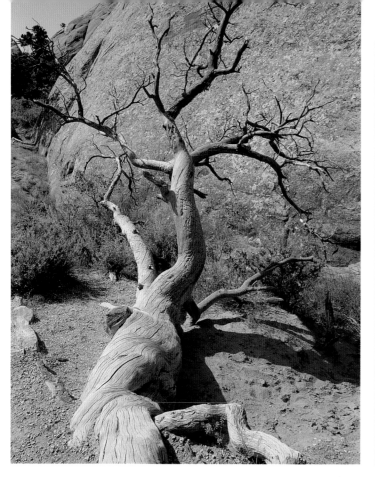
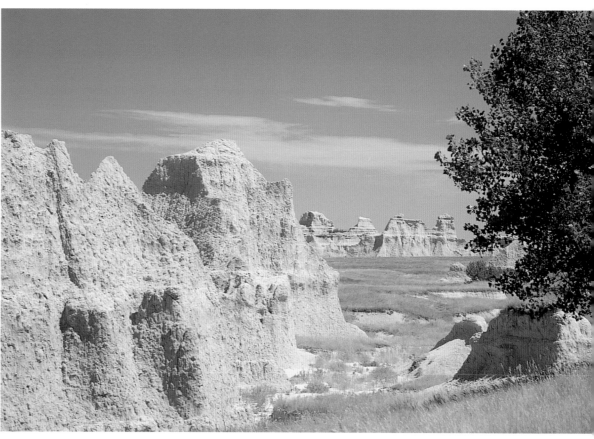
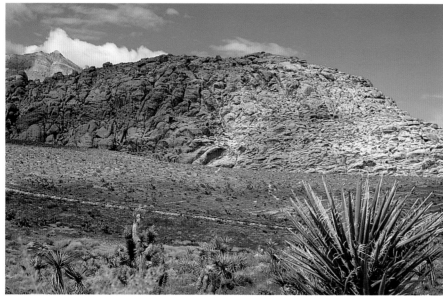
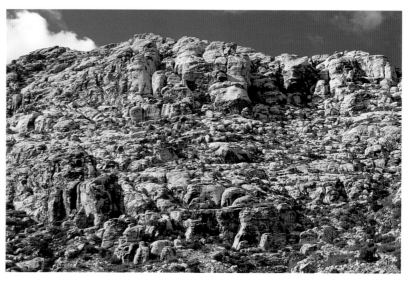

Sand

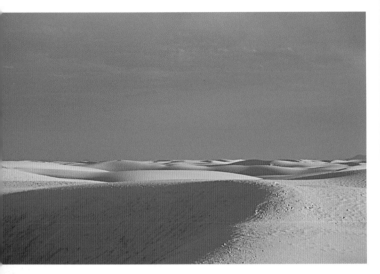

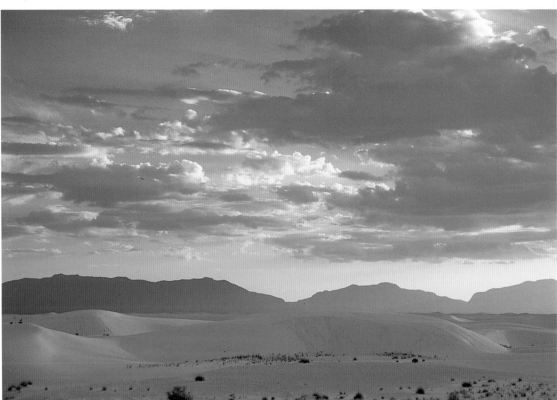

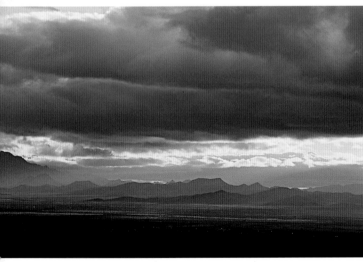

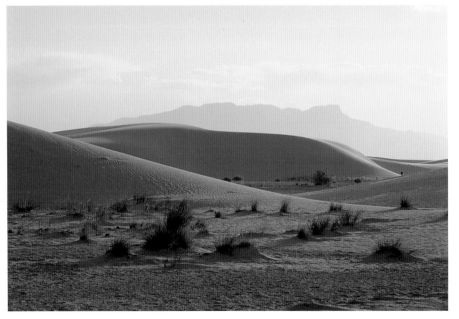

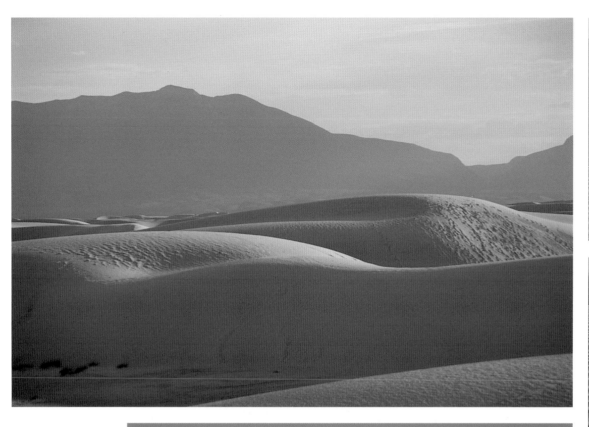

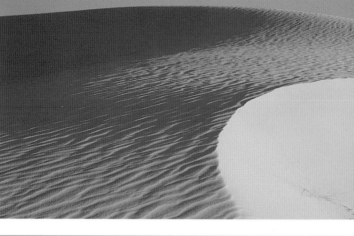

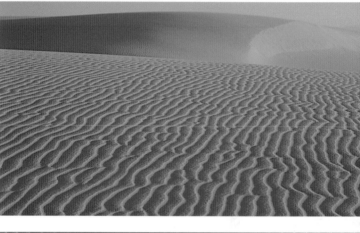

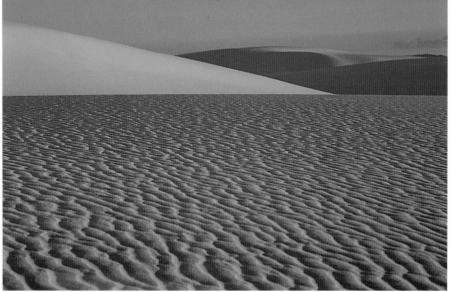

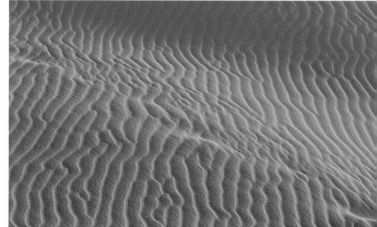

Flora

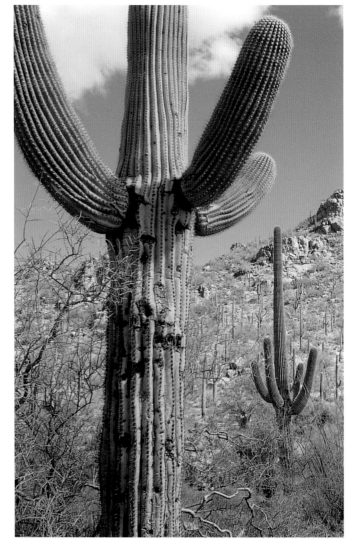

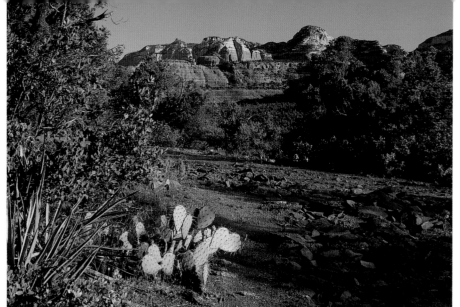

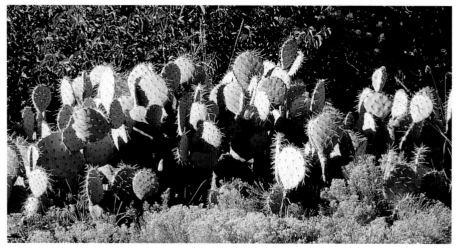

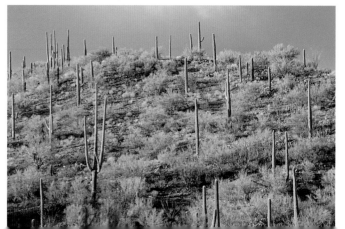

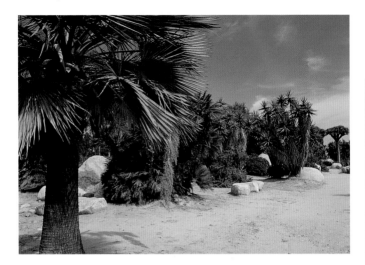

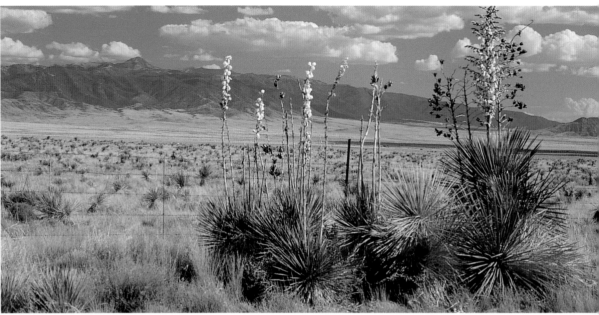

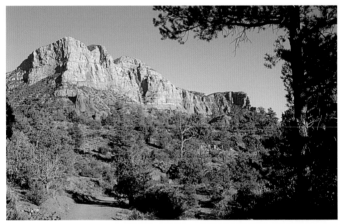

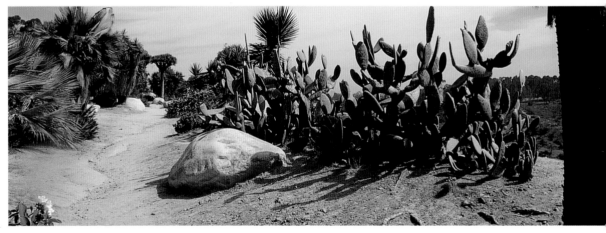

Desert Cacti in Watercolor

by Larry Weston

Materials

- 22" x 30" (56cm x 76cm) 300-lb. (640gsm) cold-press watercolor paper
- ¼-inch-thick (6mm) marine plywood board
- Drafting tape
- 1-inch (25mm) flat brush
- 2-inch (51mm) flat sky brush
- Nos. 0, 3, 6 and 16 round brushes
- Magic Rub eraser
- Masking fluid
- Masking tape
- No. 2 soft lead pencil
- Cosmetic sponge with small holes
- Natural sea sponge, with hundreds of little fingers sticking straight out
- Pro White, a commercial art product

Color Palette

Winsor & Newton Artists' Water Colour—Aureolin Yellow, Burnt Sienna, Cerulean Blue, Cobalt Blue, New Gamboge, Payne's Gray, Ultramarine Blue, Winsor Blue, Winsor Red, Yellow Ochre

Daniel Smith Extra Fine Watercolors—Quinacridone Gold, Quinacridone Red, Quinacridone Violet

L arry Weston uses a variety of reference photos in this demonstration to capture the essence of the desert, from the overcast sky to the prickly cacti.

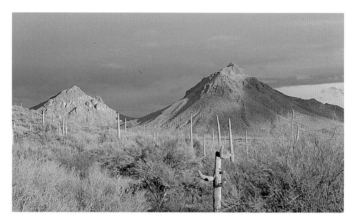

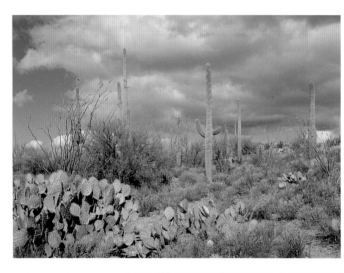

Reference photos

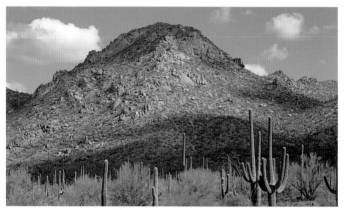

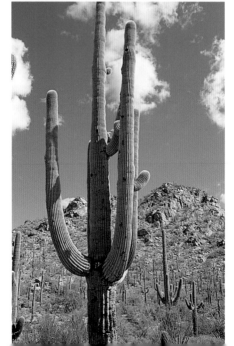

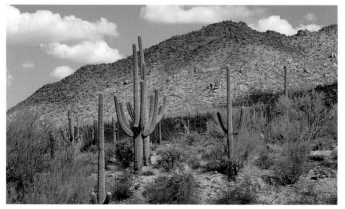

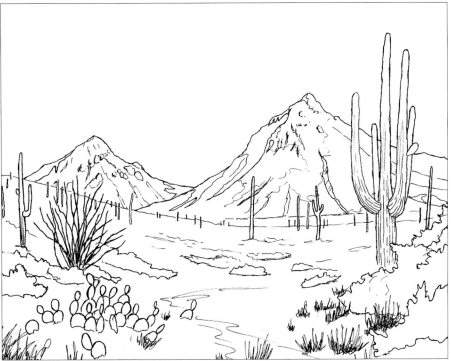

1. Prepare the Paper and Make Your Drawing

Cut the paper to the approximate size desired. Staple the dry paper onto a ¼-inch-thick (6mm) marine plywood board, which is about one inch (2.5cm) larger than the paper. Wet the paper with a sponge; lightly rub four to five times in all directions to remove any excess sizing. Allow the paper to shrink and dry. Use drafting tape on each edge of the paper to establish the exact finished size of the painting. Use a no. 2 soft lead pencil to compose your sketch and a Magic Rub eraser to remove any unwanted lines.

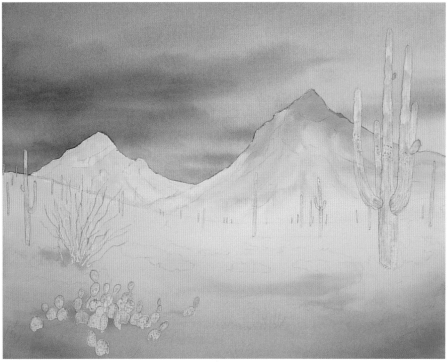

2. Paint the Sky and Begin the Mountains and Foreground

Brush masking fluid over the various cacti. To duplicate the warm glow behind the stormy sky, apply clear water while avoiding the mountains. While wet, paint a light wash of Winsor Red over the entire sky with a 2-inch (51mm) flat sky brush. Let dry. Apply more clear water. Using a 1-inch (25mm) flat brush, add the stormy clouds using various mixtures of Payne's Gray and Winsor Blue. Air dry slowly.

Brush two coats of clear water onto the mountains and the entire foreground (try not to overlap into the sky). Quickly brush a light coat of Burnt Sienna with a touch of Quinacridone Gold over the entire wet area with the 2-inch (51mm) flat sky brush. Keep the base of the mountain the lightest.

While still wet, add Burnt Sienna with a touch of Quinacridone Violet to the top portion of the large mountain and to the lower foreground. Add Winsor Red to the center portion of the lower foreground. Darken the lower corners of the painting with a mixture of Burnt Sienna and Winsor Blue. Let dry completely.

3. Paint the Mountains and Foreground Texture

Using your 2-inch (51mm) flat sky brush, apply clear water to the larger mountain followed by a light coat of Quinacridone Violet. Add Winsor Blue to the Quinacridone Violet and brush onto the upper half of the mountain. This glaze cools down the warmth of the mountain while maintaining its glow. Let dry.

Use a no. 6 round brush to apply a lighter version of the same colors directly onto the dry paper for the smaller mountain. While still wet, soften some of the edges with water. Apply clear water again to the larger mountain, then brush on a mixture of Quinacridone Violet and Winsor Blue with a no. 16 round brush to create the shadows. Allow the edges to bleed on their own and the painting to dry.

Lightly define the cracks, crevasses and shadow areas of both mountains with a light mixture of Quinacridone Violet and Winsor Blue with nos. 6 and 3 round brushes. While still wet, soften some of the edges with water. Use the same color mixture to slowly go over each area several times until the desired darkness is achieved. Allow the layers to dry between applications.

With the tip of a no. 3 round brush, add small dots of the same color mixture to the lower portion of the larger mountain to suggest bushes. Soften some with water. Use a mixture of Aureolin Yellow, Cobalt Blue and Quinacridone Violet and dot onto the base of the mountain. Lastly, blend the edges of the mountain with the sky using a no. 3 round brush.

Using a no. 6 round brush loaded with Burnt Sienna, gently drybrush the foreground of the painting. Try and hit some of the little peaks on the paper's surface while leaving many unpainted holes. While still wet, soften some of the edges with water and drybrush a mixture of Burnt Sienna and Quinacridone Red over the same damp area. Work on small areas at a time to avoid hard edges.

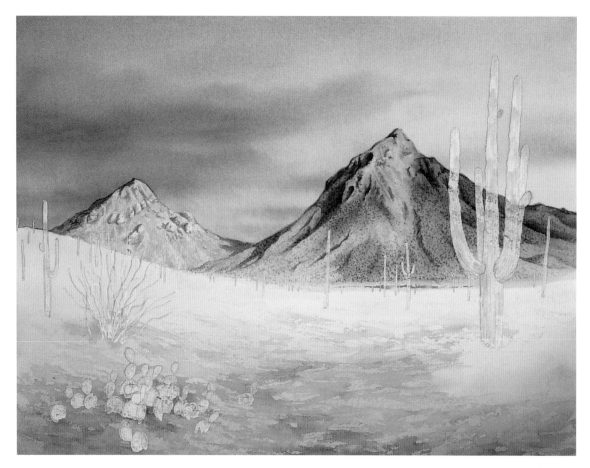

4. Add the Bushes and Intensify the Foreground Colors

Use Aureolin Yellow, Cobalt Blue and Quinacridone Gold to suggest the distant and middle-ground shrubbery. Subdue these pale greens with a slight trace of Burnt Sienna applied with a piece of a cosmetic sponge and let dry. With the same sponge, lightly apply Quinacridone Red on some of the bushes. Darken the base of the shrubs using the same colors with a no. 3 round brush.

Intensify colors and values toward the foreground. Use negative painting to suggest a few branches in the shrubs near the bottom corners of the painting. Apply the same colors with a piece of sea sponge for the dark bushes on the right. Deepen with Burnt Sienna, Winsor Blue and New Gamboge. Darken the foreground with Burnt Sienna, Quinacridone Violet and Winsor Red. Drybrush the colors into place in small areas at a time while still damp, then soften with water.

After the painting is completely dry, remove the masking fluid from the cacti by dragging a piece of masking tape, in one direction only, across the dried masking (or you may use a rubber cement pickup).

5. Paint the Cacti

Use nos. 6 and 3 round brushes with light mixtures of Cerulean Blue, New Gamboge and Burnt Sienna to establish the basic coloring and shape of the tall saguaro cacti. Let dry. Slowly add the rib details, shadows and darker values using combinations of Burnt Sienna, New Gamboge and Ultramarine Blue. Let dry. Apply a little Quinacridone Red to the lower portions of the saguaros. Use a no. 3 round brush to apply the same colors used for the saguaro to the spindly ocotillo cactus on the left—light mixtures on the right side toward the light source, and darker values on the left. Make small dots using darker values along the shady side of each stalk to suggest very small leaves (later, the leaves on the sunny side will be added using a little opaque color).

Using nos. 6 and 3 round brushes, separately paint each pad of the prickly pear cacti in the foreground with New Gamboge, Burnt Sienna and Quinacridone Violet. Leave a thin line between each pad. After the pads are dry, use both the lighter and darker colors from the saguaro and ocotillo to give the pads shape and form. When the pads are complete, glaze the white lines between them with New Gamboge and the dark green mixtures respectively.

6. Paint the Rocks and Grasses

All light areas in the foreground had the potential to become rocks. In most cases, all that a light area needs is a shadow side and a base to suggest a rock. Use the ground colors—Burnt Sienna, Quinacridone Red and Quinacridone Violet—to paint the rocks by creating a shadow below the light areas and up the left side. Use a hard edge to maintain the shadow where the rock touches the ground. Deepen by adding a little Winsor Blue to the mixtures and dropping it into the wet color.

Use a small piece of sea sponge to create the foreground grasses. Load the wet sponge with Yellow Ochre and lightly touch the paper using both downward and upward strokes to suggest grass. Apply three values and colors while the first coat is still wet. Allow the grass to dry, then add several combinations of Yellow Ochre, Burnt Sienna and Quinacridone Red. Deepen with Quinacridone Violet and Winsor Blue.

Use Quinacridone Gold, Yellow Ochre and a small amount of Pro White to add small leaves to the ocotillo on the sunny side, the sharp spines to the prickly pear and to highlight a few blades of grass, using a no. 0 round brush.

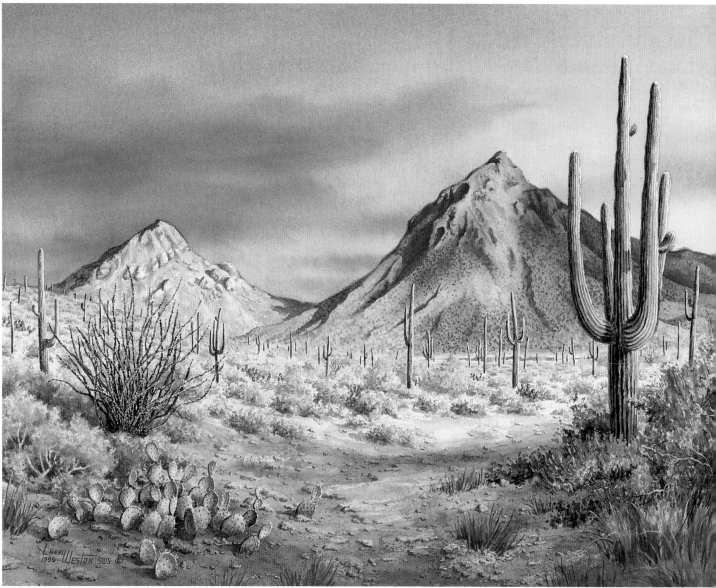

Nature's Perfection

LARRY WESTON

16" x 21" (41cm x 53cm)

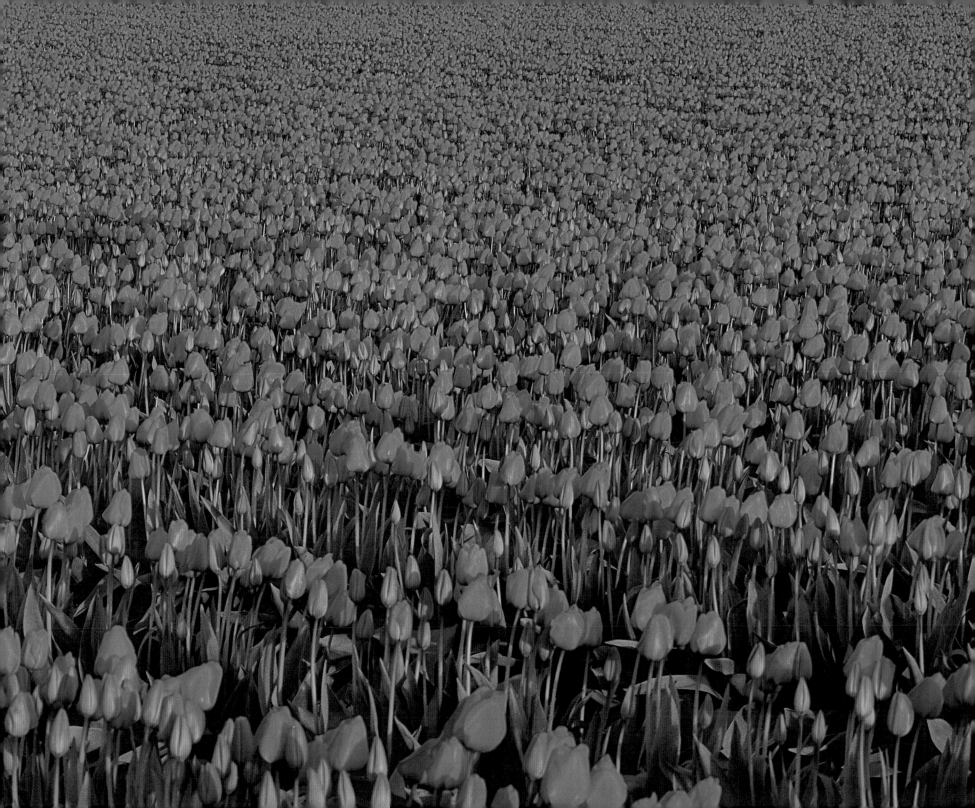

Flowers

Floral landscapes are popular, but depending on your locale,

they may be difficult to find in just the right setting.

Included in this group are images ranging from

springtime wildflowers to acres of colorful tulips.

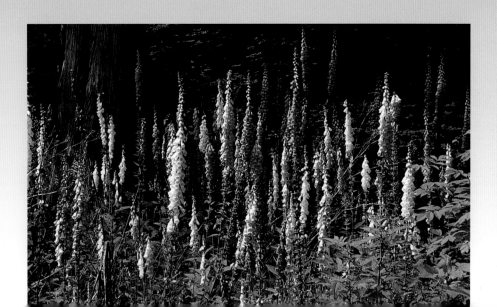

Tall Blooms and Clusters

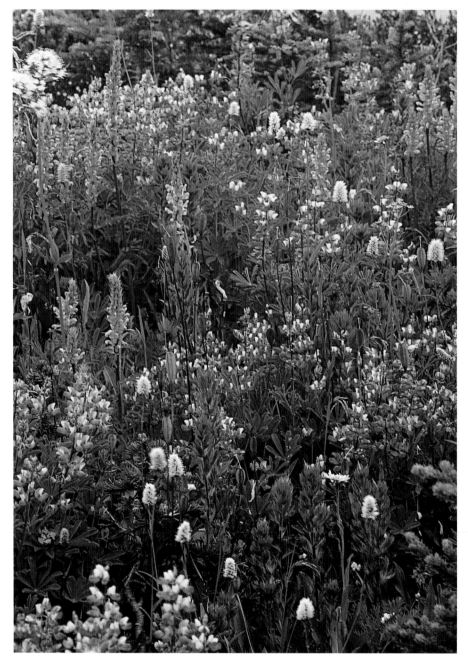

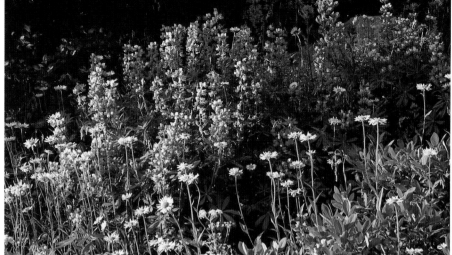

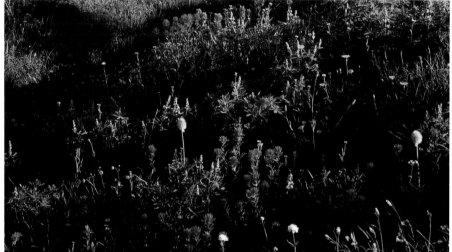

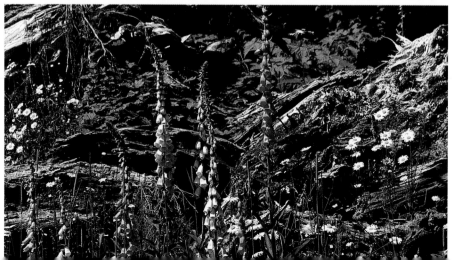

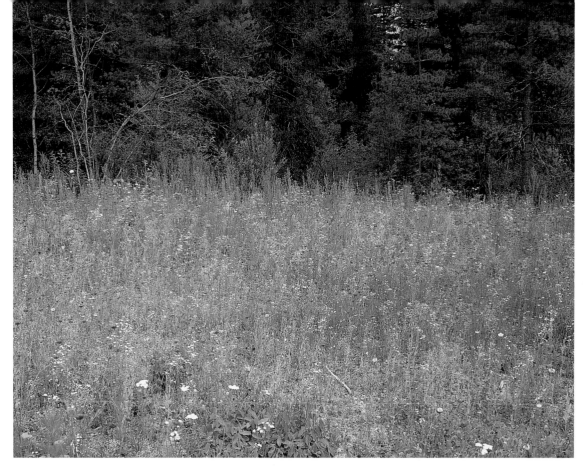

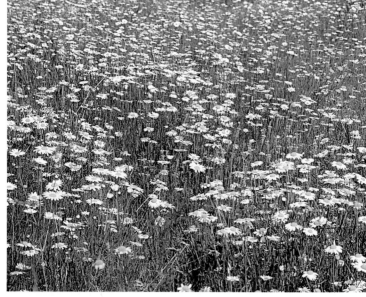

Low-Lying

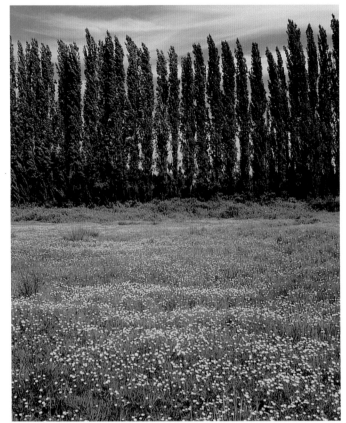

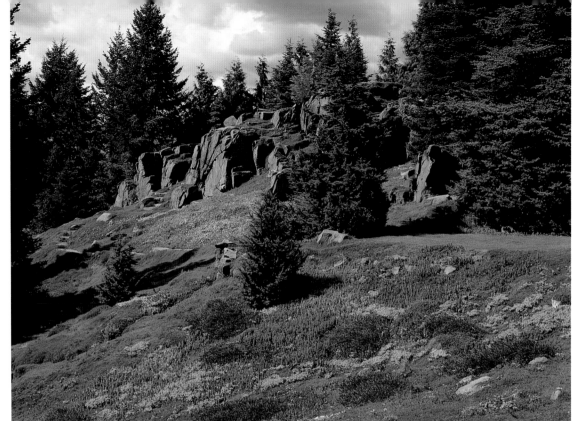

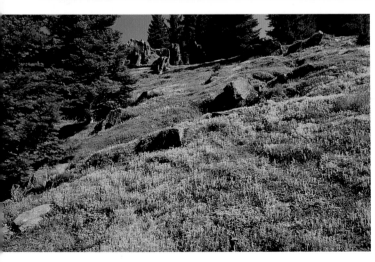

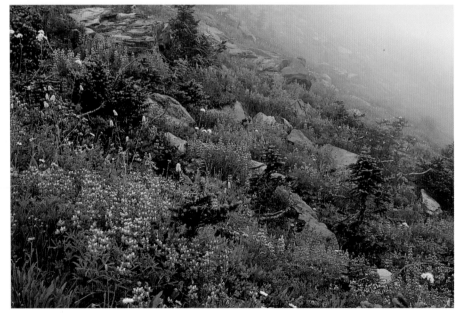

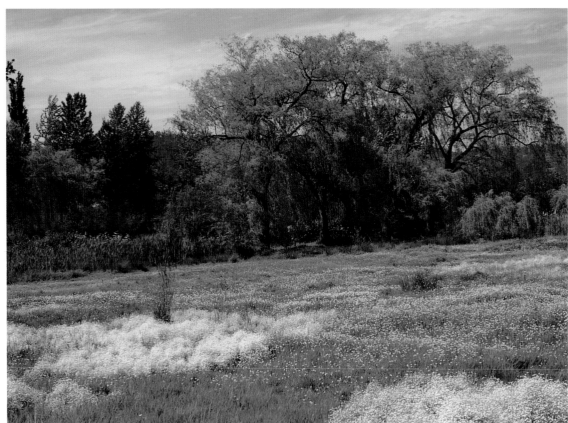

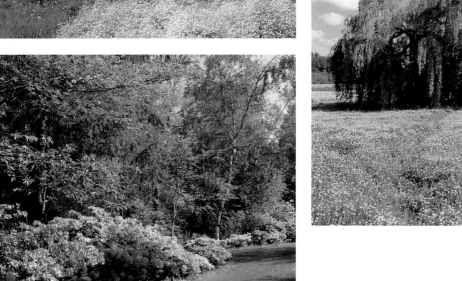

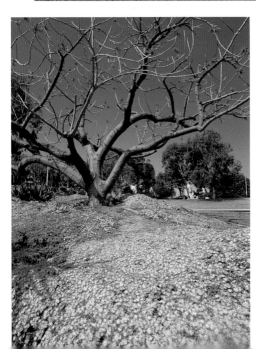

Waterside and Prairie

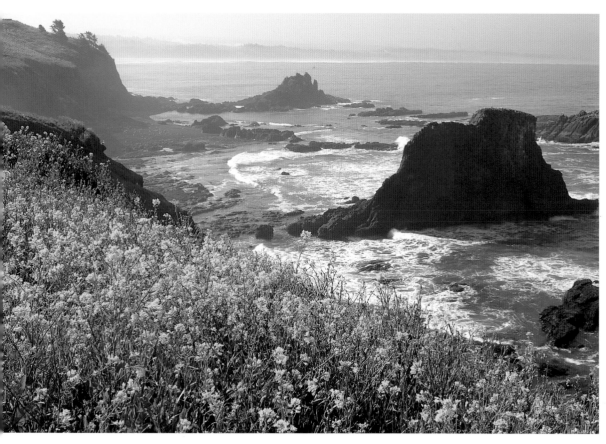

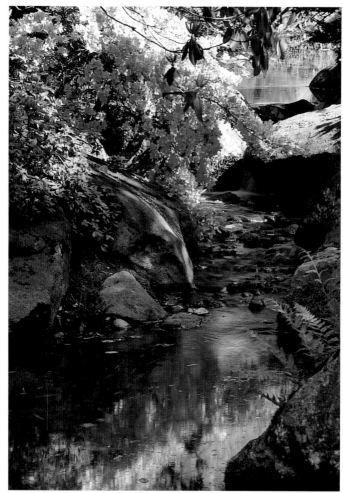

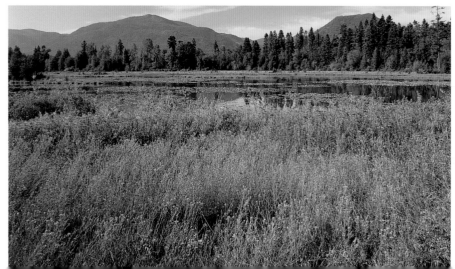

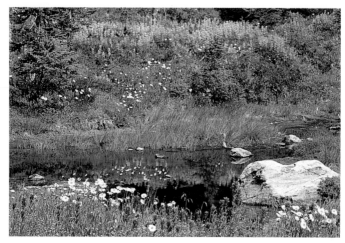

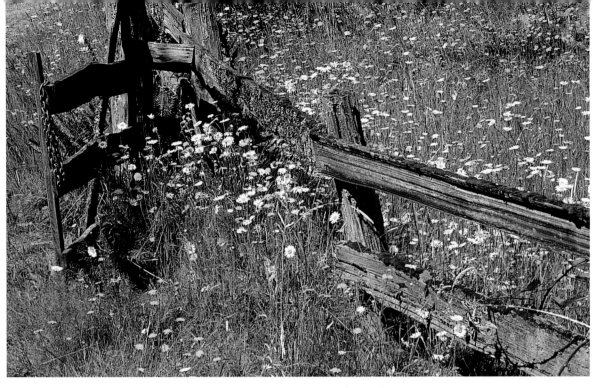

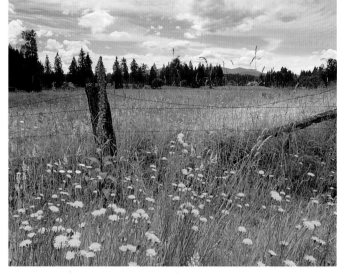

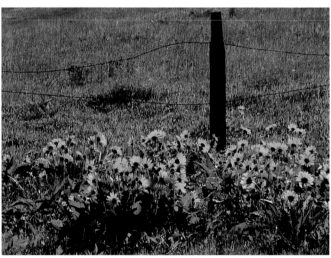

Tulips

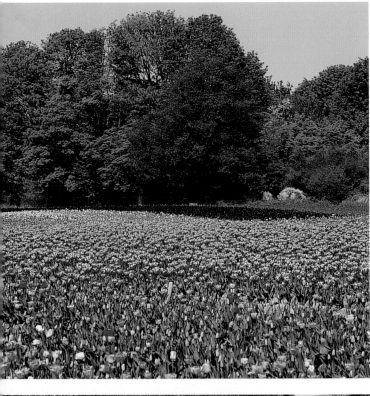

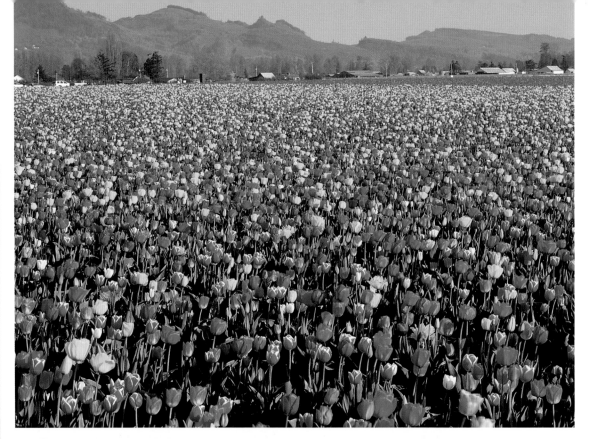

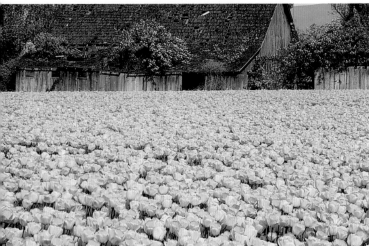

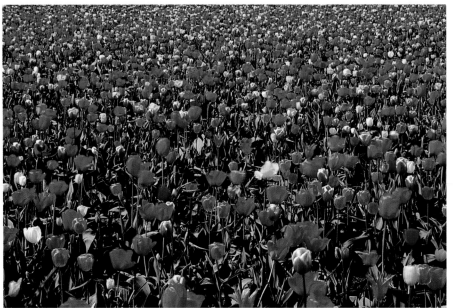

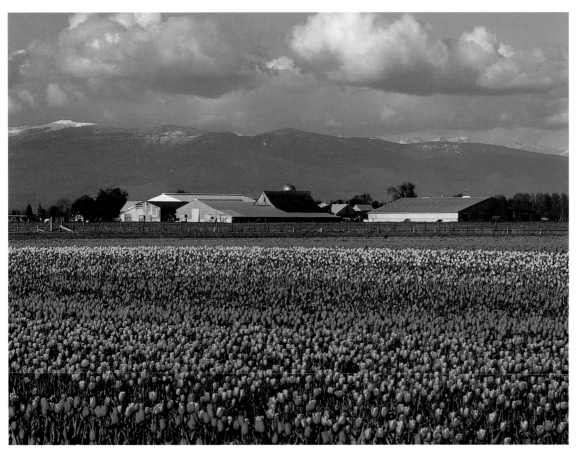

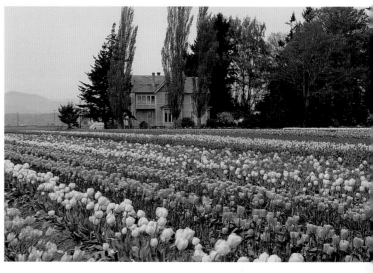

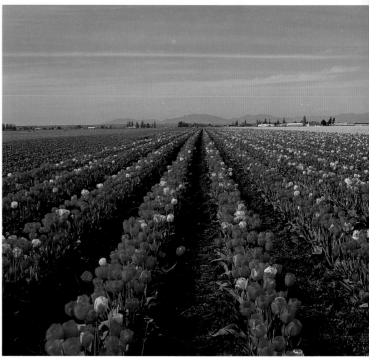

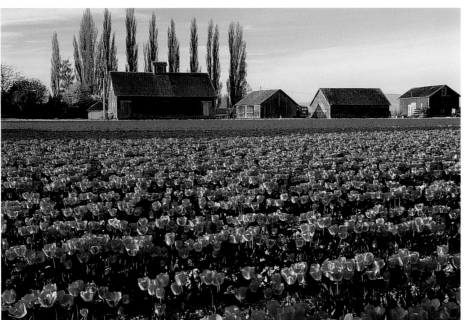

Beach With Flowers in Pastel and Acrylic

Materials

18" x 24" (46cm x 61cm) gray Ampersand pastelboard

Lascaux spray fixative

1-inch (25mm) flat housepainting brush (to apply acrylics)

No. 8 round watercolor brush

Water can (for cleaning brush)

Paper towels

Wet washcloth (for cleaning fingers)

Vertical easel (for working with pastel)

Color Palette

Golden Liquid Acrylics—Dioxazine Purple, Hansa Yellow Light, Permanent Violet Dark, Quinacridone Burnt Orange, Turquoise, Ultramarine Blue

Art Spectrum Pastels—Australian Leaf Green V580, Burnt Sienna T548, Burnt Umber V552, Flinders Blue Violet D520, Green Gray T574, Spectrum Blue T524

Derwent Pastel Pencils—Green Umber 78B, Ivory Black 67B, May Green 48B and 48D, Sepia 53B, Zinc Yellow 1D

Great American Pastels—Brown 275.0, 275.1 and 275.2; Violet 740.0, 740.1 and 740.3; White 299; Yellow 575.3

Rembrandt Pastels—Cobalt Blue 506.3, Mars Violet 538.5

Sennelier Pastels—Brown 57, Green 211, Gray 413 and 415

Unison Pastels—Green Earth GE18; Green A43; Red Earth RE6; Violet A27 and A34; Blue Violet BV1 and BV18

Peggy Braeutigam's pastel rendition of this beach in La Jolla, California, shows how the artist improves a photograph by deleting unwanted detail. The fence, light posts and other distracting elements on the background cliff and the dead branches in the foreground were omitted from the painting. Ice plant from an adjacent beach was tastefully added to the cliff and foreground, creating a serene, "natural" look.

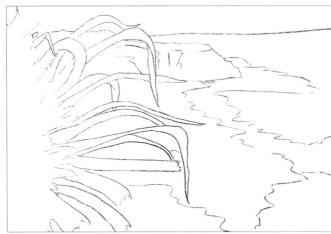

1. Draw the Layout

Draw the layout on the pastelboard with an Ivory Black 67B pencil, allowing a quarter-inch all around for framing. Use the no. 8 round watercolor brush to carefully retrace the lines with water to dissolve and set the pastel. Lightly dab any excess water around the lines with a paper towel as you work.

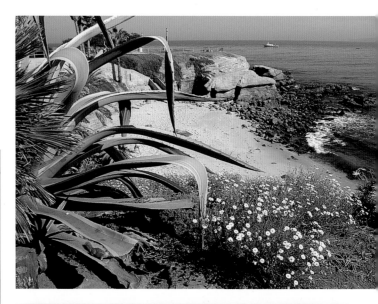

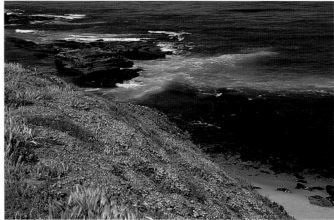

Reference photos

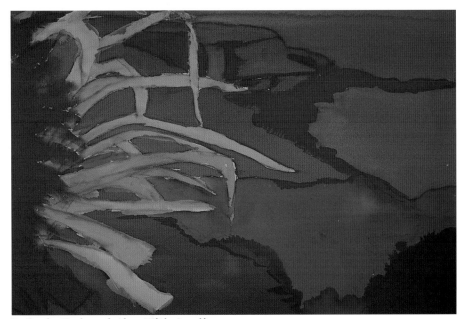

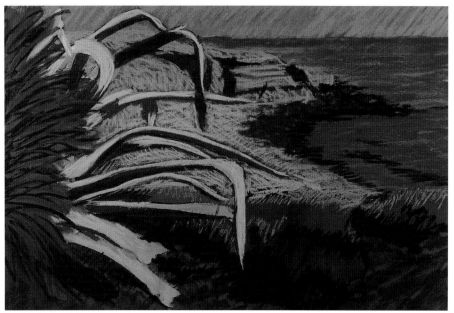

2. Begin Underpainting With Acrylics

Working on a flat surface, start at the top and apply a wash of Ultramarine Blue for the sky and ocean. Pick up excess color with a paper towel. Use Dioxazine Purple for the shoreline and shadow areas on the distant bluff and Quinacridone Burnt Orange for the bluffs, beach and foreground. Underpaint the floral bushes with Turquoise and the palm leaves on the left with Permanent Violet Dark. Allow to dry before using Hansa Yellow Light for the long, thin leaves (this will help prevent bleeding at the edges).

3. Block In First Pastel Layer

Always work pastels on a vertical easel. Starting at the top, keep all strokes loose, allowing the underpainting of acrylic to show through. Do not use your fingers anywhere at this stage. When finished, smack the back of the board to loosen any dust.

Use the following pastels for the different elements:

Spectrum Blue T524—sky area

Blue Violet BV18—ocean

Flinders Blue Violet D520—shoreline and shadow area of bluffs

Burnt Sienna T548 and Violet A34—bluffs

Burnt Sienna T548—beach

Violet A34 and Red Earth RE6—shoreline

Green Gray T574, Flinders Blue Violet D520 and Violet A27—long, thin leaves

Flinders Blue Violet D520 and Green Earth GE18—palm leaves

Flinders Blue Violet D520 and Violet A34—shadows of floral bushes

Red Earth RE6—foreground

4. Refine With Second Pastel Layer

Many different combinations of colors are used to create the depth of the painting.

Proceed with the following sections, using the colors listed:

1. **Sky.** Use the broad side of Blue Violet BV1 to cover the sky area. Blend with your fingers.

2. **Ocean.** At the horizon and throughout the ocean, apply Blue Violet BV18, Spectrum Blue T524, Cobalt Blue 506.3, Flinders Blue Violet D520 and Blue Violet BV1. Use White 299 and Blue Violet BV1 for the waves, but beforehand lightly cover the area with Lascaux spray fixative to somewhat seal the existing pigments.

3. **Bluffs.** Start with the darkest values to create form. Use Flinders Blue Violet D520; Burnt Umber V552; Burnt Sienna T548; Brown 275.0, 275.1 and 275.2; Mars Violet 538.5; Gray 415 and Brown 57.

4. **Rocks along the shoreline.** Use Flinders Blue Violet D520, Brown 57 and Brown 275.0. Define the shapes with Brown 275.1 and 275.2, Mars Violet 538.5 and Gray 415.

5. **Beach and shoreline.** Use Burnt Umber V552, then Gray 413 and 415. Work over with Flinders Blue Violet D520 and Brown 275.1.

6. **Long, thin leaves.** Use Australian Leaf Green V580, Flinders Blue Violet D520, Green Earth GE18 and Brown 275.1.

7. **Palm fronds.** Randomly place strokes of Green Earth GE18 over the Flinders Blue Violet D520. Lightly spray entire painting with Lascaux spray fixative.

8. **White flower bushes.** Use Green A43 and Flinders Blue Violet D520 for the stems. Do not blend with fingers anywhere. Apply Green 211, Green Earth GE18 and Australian Leaf Green V580 randomly throughout.

9. **Specks of flowers.** Scrape fingernail along the edge of pastel stick using Blue Violet BV1, Yellow 575.3 and White 299. Firmly apply pressure to the specks, press and lift; do not smear.

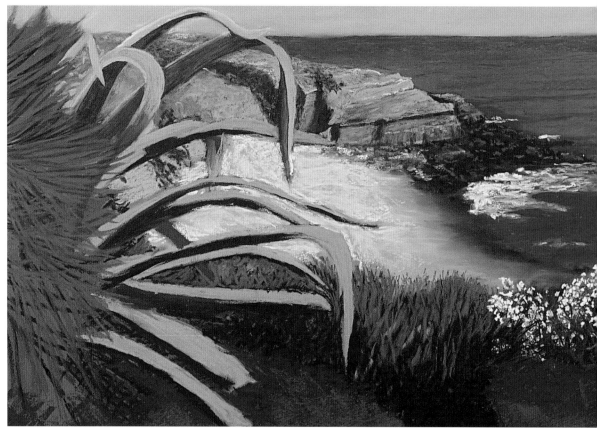

10. **Whole flowers.** Use White 299, Yellow 575.3 and Violet 740.0 and 740.1.

11. **Foreground dirt.** Redefine shadows with Flinders Blue Violet D520 and Brown 275.0.

12. **Flower bush shadows and foreground.** Use Flinders Blue Violet D520. Finish the foreground with Brown 275.1 and 275.2.

Handle With Care
Use your pastels with a light touch. You can always scrape or brush it off if you don't like the shapes.

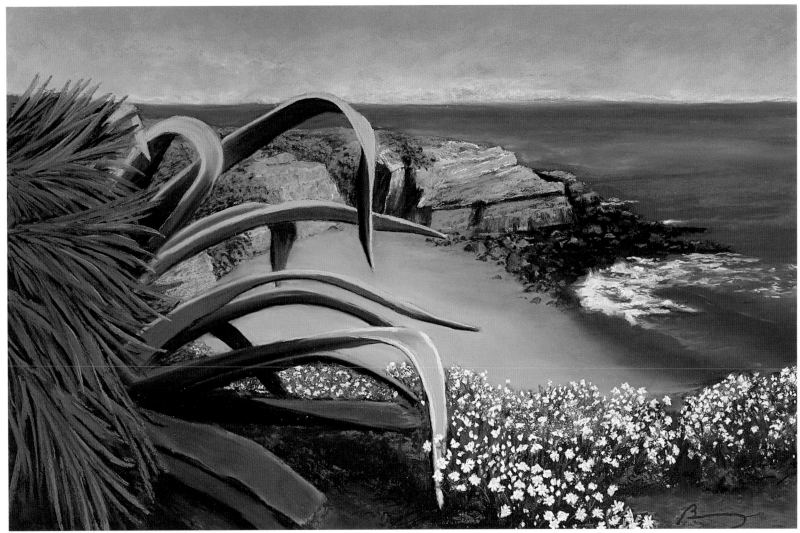

Secluded Beach
PEGGY BRAEUTIGAM
17" x 23" (43cm x 58cm)

5. Finger-Blend and Add Finishing Touches

Use your fingers to blend various areas—the foreground dirt, ocean, plant leaves, beach and shoreline—taking care not to smudge. Spray periodically with Lascaux spray fixative. To finish the sky, use the broad side of the pastels to mix Spectrum Blue T524 and Violet 740.3 into the Blue Violet BV1 at the horizon line, then blend.

Using Derwent pencils Ivory Black 67B and Sepia 53B, redefine the shadow areas on the long, thin leaves. Draw in yellow lines on these leaves with Zinc Yellow 1D and May Green 48B and 48D. Highlight with May Green 48B. (You'll notice that the thin leaf above the horizon line was removed. The leaf was brushed out and the area washed with water and allowed to dry before repainting the area.)

Highlight the tips of the palm leaves with May Green 48B and Brown 275.1. Redefine some shadowed areas with Flinders Blue Violet D520. Finish the foreground flowers with the pastels used in step 4. For the flowers and grass on top of the background cliffs, use Green Earth GE18, Green A43 and Violet 740.0 and 740.1. Only use fingers to lightly tap the top of the flowers and grass. Mute the values as necessary. Draw the strokes in the direction that you want the eye to follow.

Redefine crevices in the bluffs with Ivory Black 67B and Green Umber 78B. Highlight areas of the flower bushes with May Green 48B and 48D. Don't finish with spray fixative at this point; all of the light values will be darkened too much.

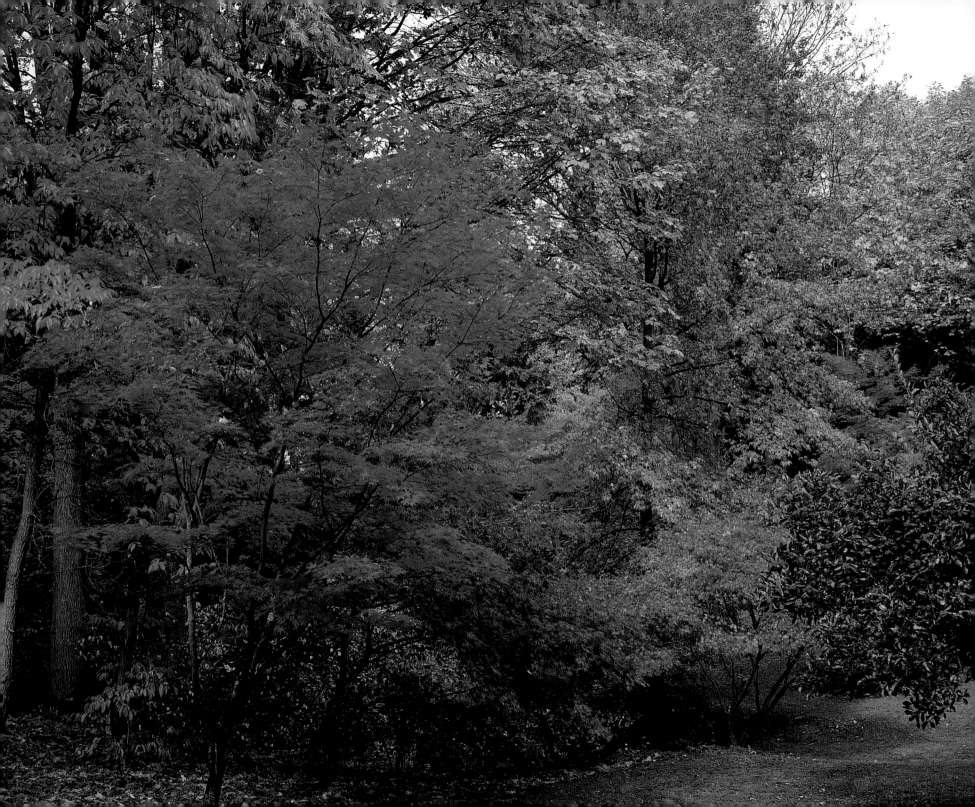

Seasons

This section focuses on settings and details

as dictated by the different seasons, from radiant

spring blooms to snow-covered evergreen boughs.

Spring

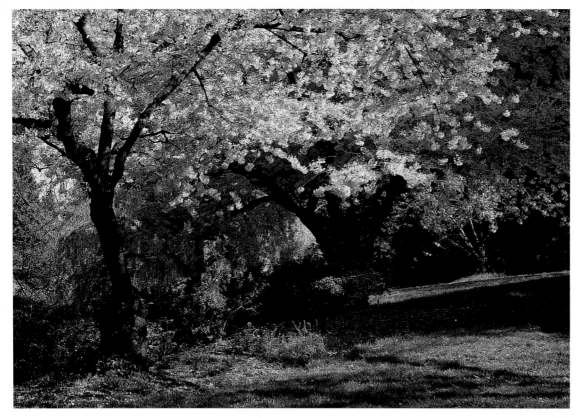

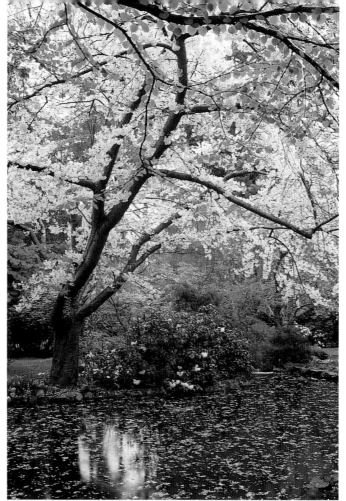

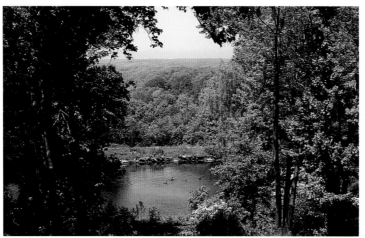

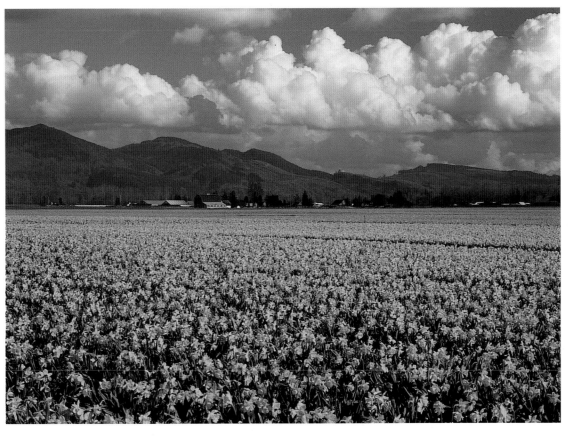
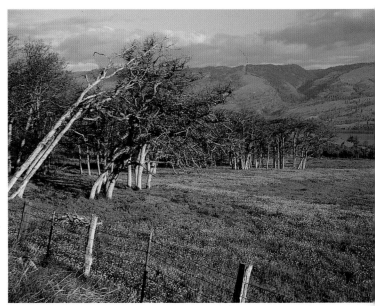
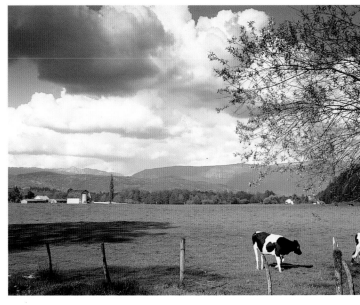
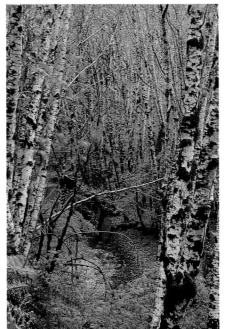
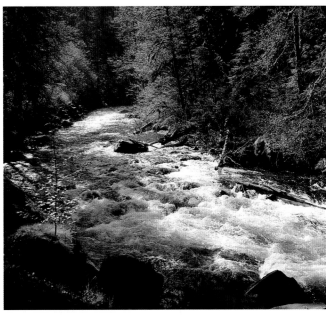

Summer

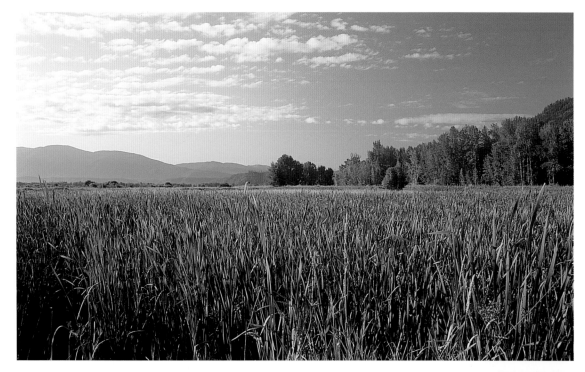

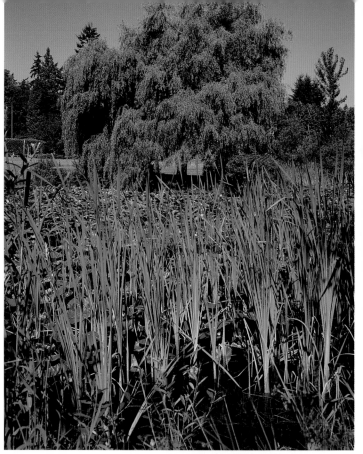

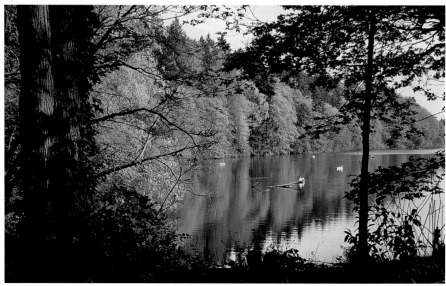

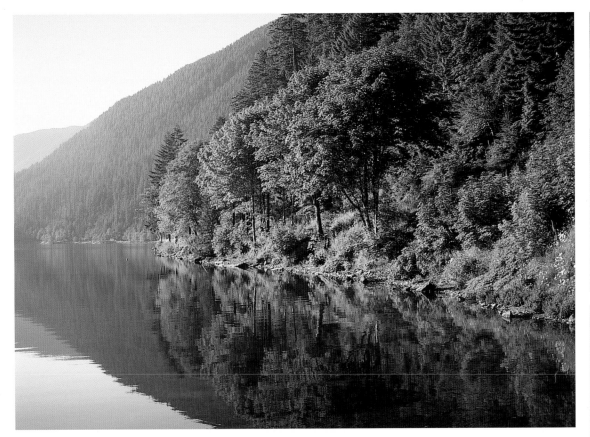

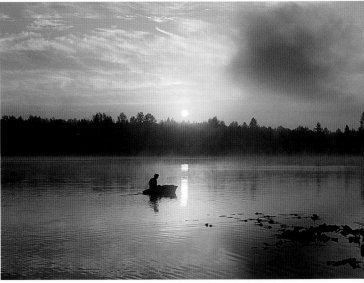

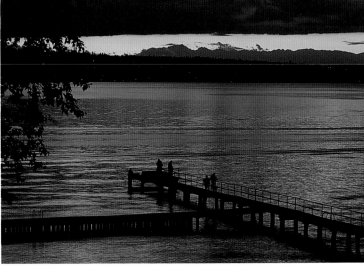

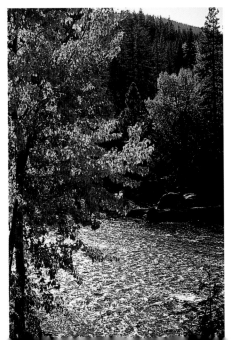

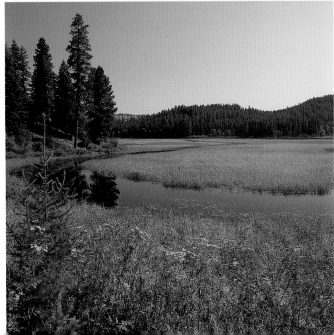

Autumn

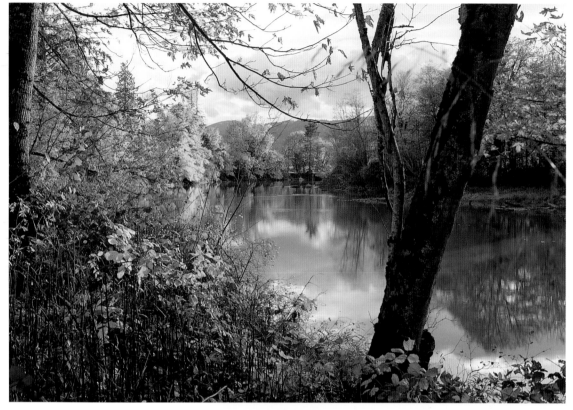

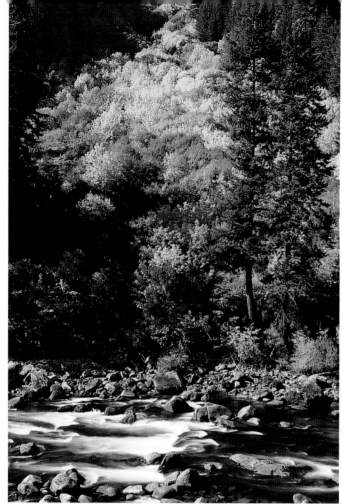

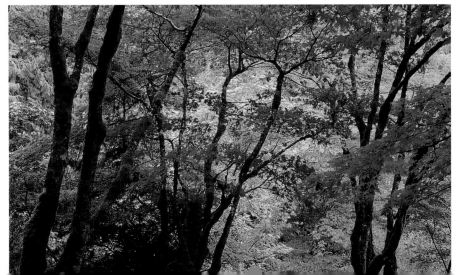

Winter

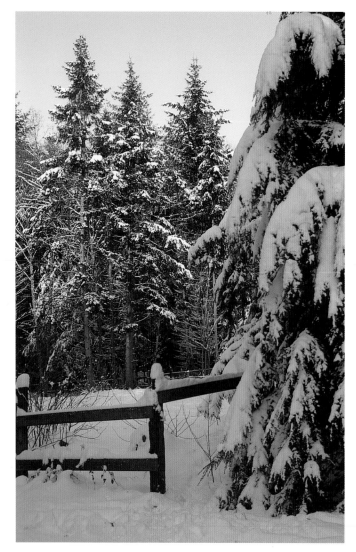

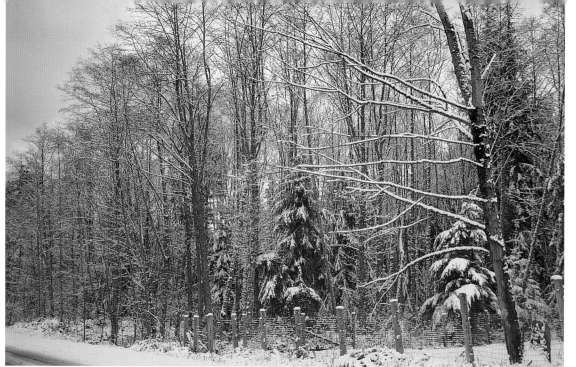

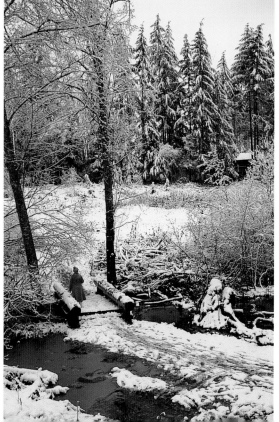

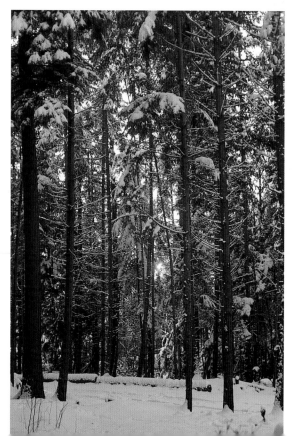

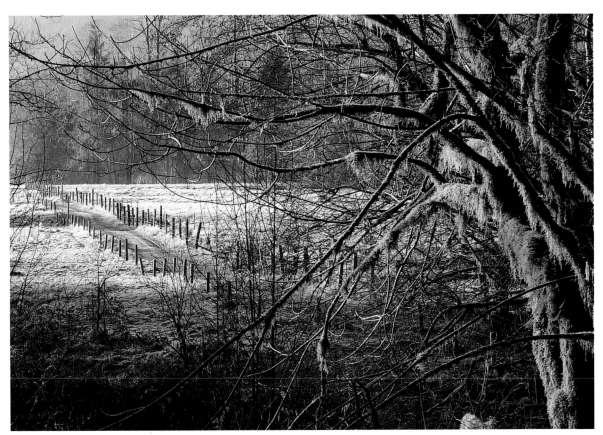

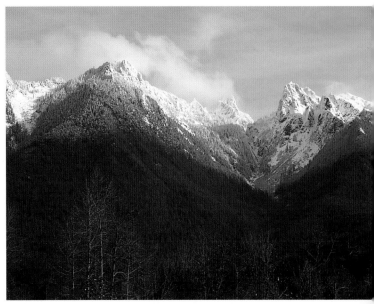

Autumn Mountain Scene in Mixed Media

Materials

Strathmore 500 series hot-pressed illustration board

100% rag drafting paper

Graphite transfer paper

White colored pencil

2B graphite pencil

Magic Rub eraser

Crow quill pen

Higgins India ink

Pencil sharpener

Eraser shield

Grumbacher Miskit liquid frisket

Old brush (for applying Miskit)

Palette

1-inch (25mm) wash brush

Nos. 1 and 10 round brushes

Color Palette

Liquitex Acrylics—Burnt Umber, Deep Brilliant Red, Mars Black, Napthol Crimson, Phthalo Blue, Prussian Blue, Burnt Sienna, Raw Sienna, Raw Umber, Titanium White, Viridian Green

Prismacolor Nupastels—Green 228-P and 298-P; Red 226-P, 256-P, 234-P and 236-P; Brown 293-P

You may have seen this vista before. That's because it's one of the most photographed spots in North America: Artist Point in the Mount Baker National Forest, about sixty miles east of Bellingham, Washington. On a beautiful autumn day like the ones in these photographs, the most difficult problem in photographing this scene is keeping the other photographers out of the picture!

Nancy Pfister Lytle has captured the overwhelming beauty of Mount Shucksan reflected in Picture Lake by painting the best features of two reference photos in acrylic, ink and pastel.

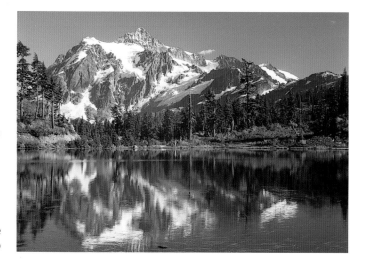

Secondary reference photo

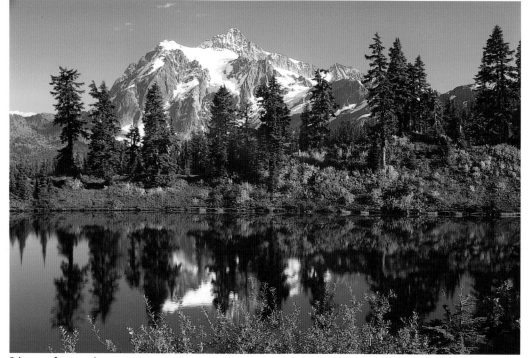

Primary reference photo

1. Make the Line Drawing

Make a photocopy of your main reference photo, and draw a grid on the photocopy with a white colored pencil. Draw another grid in proportion for the finished size using your 2B graphite pencil on 100% rag drafting paper. With graphite transfer paper, transfer your drawing onto a sheet of Strathmore 500 series hot-pressed illustration board.

2. Begin the Painting

With a 1-inch (25mm) wash brush, wet your board with water. Next, lay in a wash of Phthalo Blue for the sky. With Miskit and an old brush, mask in the white snowy areas of the mountains and the area where the foliage will be placed. Let the masking dry. Wet your paper again and lay in a wash with a watery solution of Phthalo Blue, Burnt Sienna and Titanium White over the mountains. For the water, mix Prussian Blue, Burnt Umber and Mars Black and lay in a wash with a 1-inch (25mm) wash brush. Paint around the snowy areas of the mountains in the reflection. Paint the sky reflection in the two lower corners of the painting with Phthalo Blue. Let the painting dry.

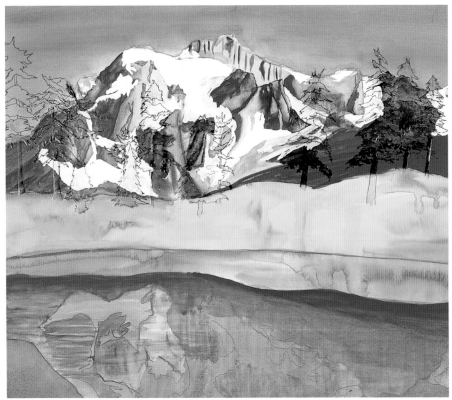

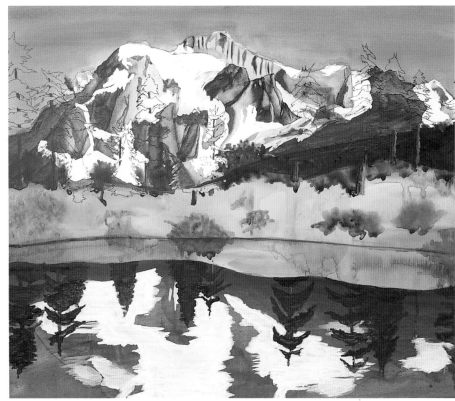

3. Paint Darkest Masses of Mountains and Begin Trees and Foliage

Lay a mound of Mars Black on your palette straight from the tube. Use a no. 10 round brush for the darker masses of the mountains. Dip your brush into a mixture of Phthalo Blue, Burnt Sienna and Titanium White first, then dip your brush into the Mars Black. Vary the amount of Mars Black depending on the darkness of the area you are painting. (Squinting your eyes will help you see the darkest areas of your reference photos.)

With a 1-inch (25mm) wash brush, lay in a wash of Raw Sienna for the foliage area. Allow your paper to dry, then remove the Miskit. Ink in the middle-ground trees with a crow quill pen and India ink. Let the ink dry for at least twenty-four hours. Next, mask out the trees. Wet the area of foliage reflection and wash in a mixture of Deep Brilliant Red and Napthol Crimson. Let the paints flow to add some texture.

Lay in another wash of the mixture of Prussian Blue, Burnt Umber and Mars Black for the water, adding a touch more Mars Black to darken.

4. Add Some Foliage and Paint the Reflections

With a no. 1 round brush, paint in some light patches of Viridian Green for some of the foliage. With a thicker Viridian Green, paint in more foliage around the trees. Let dry, then remove the masking. With Raw Umber, paint the tree trunks. For the light areas where the sun hits them, paint in Raw Sienna.

Wet your paper and paint in the tree reflections with a thick mixture of Viridian Green and Mars Black using your no. 1 round brush. Paint the mountain reflections with a mixture of Prussian Blue, Napthol Crimson and Mars Black using your no. 10 round brush. Also use your no. 10 round brush with Titanium White to paint in the white reflections.

5. Finish the Trees and Foliage and Add Finishing Touches

For the trees and foliage, work from dark to light using Nupastel Green 228-P (light) and 298-P (dark); Red 226-P, 256-P, 234-P and 236-P; and Brown 293-P. Lay in the dark green underpainting for the trees and foliage with Green 298-P, and add highlights with Green 228-P.

Use Raw Umber and Burnt Sienna to paint the tree trunks reflected in the water. Use a no. 1 round brush with Titanium White to stroke across the snow reflections for ripples in the water.

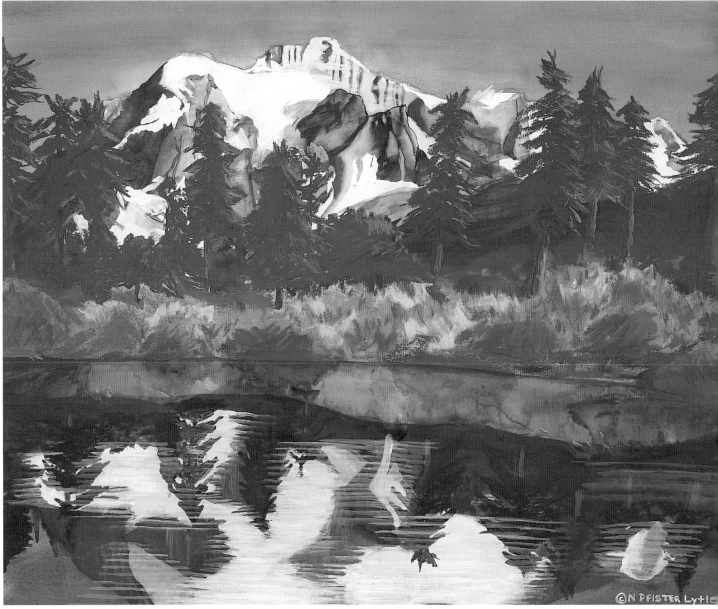

Picture Lake

NANCY PFISTER LYTLE

16" x 20¼" (41cm x 51cm)

Peggy can recall the first time she pressed hard on a crayon and produced a vibrant red barn and yellow sun. She fell in love with color at the tender age of four years. Not being a graduate of an art school, academically Peggy would be considered a self-developed artist. However, acknowledgment must be given to those artists whose courses and workshops she has attended over the years. In that time she studied all the elements of fine art and learned the application of oils and acrylics as well as pastel. She also learned calligraphy and for several years was a freelance calligrapher. In 1985 she was introduced to pastels, and that has been her preferred medium ever since.

Peggy uses many different techniques to create her pastel paintings. One of them involves blocking in the initial composition with liquid acrylics, and another is to use an all-black or brightly colored surface. Each produces an entirely different appearance of the finished product.

Peggy's work has been accepted into numerous national and international art competitions, including the International Association of Pastel Societies (IAPS)

Second Biennial Convention Exhibit and its First Museum Exhibit, and the South West Artist's Open Multi-Medium Competition. Her awards include the Award of Merit in the Northwest Pastel Society and Pastel Painters' Society of Cape Cod. Her paintings have been published in the August '94 and July '99 issues of *The Artist's Magazine*. She was also included on a CD-ROM produced for Eastman Kodak by VAMP, Inc. entitled *A Showcase of American Pastel Artists*.

Peggy has conducted workshops, demonstrations and lectures in the U.S. for many years. A charter member of the Northwest Pastel Society, and signature member since 1987, Peggy was president of the three-hundred-member international society from 1992 through 1997. She is also a signature member of the Pastel Painters' Society of Cape Cod and a member of the pastel societies of Oregon, Colorado and New Mexico. Currently she is the IAPS chairman of exhibitions. IAPS is an umbrella organization of forty pastel societies worldwide, and sponsors biennial conventions and annual competitions held in galleries and museums throughout the U.S.

Carolyn E. Lewis

"Capturing the mood of the moment and the effect of light is an important goal in my work." A commendable quality of Carolyn's work is the feeling one experiences of actually being in the scene while viewing her strongly designed landscapes. "But most of all," Carolyn says, "I enjoy the process of creating art and communicating the atmosphere and drama of my subject."

From a very young age, Carolyn dreamt of being an artist. Now living in Cuyahoga Falls, Ohio, she splits her time between her responsibilities as a gallery director for the Lawrence Churski Gallery and her painting career. Also, for the past five years she has been an instructor at the Cuyahoga Valley Art Center, teaching landscape painting. From 1996 through 1998 she was president of the Akron Society of Artists (Ohio), and she remains on its board of directors.

Carolyn's art is inspired by nature, wildlife and people. It is sensitive without being overly sentimental. Her commissioned portraits of individuals, paintings of animals and her powerful landscapes are steadily gaining acclaim in local, regional and national art circles.

Beyond her formal education, she has studied with Jack Richard, Marc Moon, Dino Massaroni, Burton Silverman and Albert Handel, among others. She also finds studying the Masters in museums to be extremely effective.

Along with several solo exhibitions, Carolyn has been selected to exhibit in local, regional and national art competitions, winning many awards. One of her more recent awards was an honorable mention in the top six out of 9,000 entries for *The Artist's Magazine* 1998 National Landscape Competition.

Carolyn is a signature member of the Akron Society of Artists, Cuyahoga Valley Art Center and Oil Painters of America (Illinois); a charter member of Portrait Society of America (Florida) and The Portrait Guild (Ohio); and a general member of the American Society of Classical Realists (Minnesota) and the Catharine Lorillard Wolfe Art Club (New York).

Nancy Pfister Lytle

Nancy Pfister Lytle is a fine artist who has won numerous awards for her art. Her work hangs in public and private collections across the U.S. and abroad. In addition to being a working artist, she has been a technical illustrator and is an editor for North Light Books. Working mostly in acrylics, she also paints in watercolor and mixed media.

One of her works, *Northern Bound on the Underground Railroad*, received statewide attention in Ohio during an exhibit on the history of the Underground Railroad in southwestern Ohio. The exhibit was held at the Pump House Art Gallery in Chillicothe.

She has a number of gallery affiliations and is a member of several art societies. A native of Wilmington, Ohio, she enjoys experimenting with three-point perspective. Nancy paints in a realistic style.

Mary Sweet

Mary Sweet has drawn and painted since childhood. She received a B.A. in Art with Honors in Humanities from Stanford University and also an M.A. in Art from Stanford. She worked mostly in acrylics until 1991 when she began trying some new media such as artist's books, monotypes and woodblock prints done Japanese-style with watercolors. But she continues to paint in acrylics too, and the subject matter is nearly always landscape, especially the wild, colorful and unspoiled lands of the American West.

Mary has had work accepted in juried shows across the U.S. since the 1960s, including a number of Western Federation of Watercolor Societies Annuals since 1988. Her woodblock prints have toured the Pacific Northwest in the Moku Hanga Traveling Exhibition and went to Kyoto, Japan, in 1998 and 1999. Mary has had many one- or two-person shows, the most recent being at the Fine Arts Gallery at the New Mexico State Fairgrounds in 1999.

Her awards include Best of Show at the Western Federation of Watercolor Societies 21st Annual in San Antonio, Texas, in 1996; first, second and third place respectively at the New Mexico State Fair in 1997, 1998 and 1999; a Merit Award at Arizona Aqueous 1990; and the Lena Newcastle Award at the American Watercolor Society 121st Annual.

Books Mary has been included in are *The Acrylic Painter's Book of Styles & Techniques* (Rachel Wolf, North Light Books, 1997), *Enliven Your Paintings With Light* (Phil Metzger, North Light Books, 1993), *Splash* (Greg Albert and Rachel Wolf, North Light Books, 1991), *Painting the Landscape* (Elizabeth Leonard, Watson-Guptill, 1984) and *The American Artist Diary, New America* (University of New Mexico, 1982), as well as several *Who's Who* books, including *Who's Who in American Art* and *Who's Who in the West*. She also has appeared in *Watercolor Magic* magazine, *Watercolor Magazine*, *Plateau Magazine of the Museum of Northern Arizona*, *American Artist* magazine and *Instructor Magazine*.

Mary is a signature member of the New Mexico Watercolor Society and the Western Federation of Watercolor Societies. Her work is in private and public collections, and she has been a juror for the New Mexico Arts and Crafts Fair, Southwest Arts Festival and 1% For Art.

Larry Weston

Larry Weston was born and raised in Phoenix, Arizona. His parents recognized his art talents at an early age and enrolled him into oil painting classes while in the first grade. He has been painting and teaching art ever since. Larry and his wife, Shirley, presently reside in a suburb of Dallas, Texas.

While stationed in Germany with the U.S. Air Force, Larry began his art teaching career. At the age of nineteen he started conducting oil painting classes for other servicemen in his off-duty time. While in Europe, he painted most of the castles along the Rhine and Moselle rivers in Germany as well as many scenes from France and Switzerland. After his discharge from the service, he enrolled in college majoring in commercial art. During this period, he also studied and completed the Famous Artists School's Commercial Art, Illustration and Design course. Later, he completed the Famous Artists School's Fine Art and Painting course.

His first art position was with the American Quarter Horse Association as a commercial artist in Amarillo, Texas. While there he continued teaching art on the side. In 1964, he moved to the Dallas/Fort Worth area. He spent the next ten years with Teledyne Geotech as their art director. While there he conducted painting classes in oils, acrylics and watercolor for company employees after business hours. From Teledyne Geotech, he went to work for a Halliburton company, Otis Engineering Corporation, as the graphic arts department manager. In 1982, he resigned from Otis to pursue a full-time career in his first love, as a fine arts painter and art instructor.

To date, Larry has conducted over four hundred watercolor and oil painting workshops and classes. In addition, he has done several hundred demonstrations for various art organizations. For four years he was a traveling watercolor instructor for the University of Oklahoma's continuing education department, conducting many one- and two-week watercolor workshops throughout the U.S., Mexico and Europe. In addition to being a well-known art instructor, he has served as a judge for many local, regional and national shows.

Larry's work has received numerous national and regional honors and awards. His paintings hang in major galleries and private collections across the U.S. and in Europe. Larry is a signature member and a past president of the Southwestern Watercolor Society (SWS) and an associate member of the National Watercolor Society, as well as a member of many other well-known art organizations.

INDEX